XV

FIFTEEN SANTA FE ARTISTS

CURATOR'S ESSAY BY JAMES MANN

PHOTOGRAPHS BY ROBERT BELL

LAS VEGAS ART MUSEUM

BELL TOWER EDITIONS

This book was produced in association with the
Las Vegas Art Museum for its Fifteen Santa Fe Artists
exhibition held March 18 – May 22, 2005

9600 West Sahara Avenue
Las Vegas, Nevada 89117
702-360-8000
www.lasvegasartmuseum.org

Published by
Bell Tower Editions
2108 Foothill Road
Santa Fe, New Mexico 87505
505-983-3055

Designed by Mark Diederichsen

©2005 Bell Tower Editions
First Edition
ISBN 0-9728594-4-6 Paper Back
ISBN 0-9728594-5-4 Hard Cover

TABLE OF CONTENTS

PUBLISHER'S ACKNOWLEDGMENTS

This book is the result of large and significant endeavors on the part of several individuals other than the authors:

Karen Barrett, Executive Director of the Las Vegas Art Museum, who has fostered this exhibition; Ellen Grossman and Oscar De Los Reyes of the LVAM staff, whose technical assistance has been invaluable;

My parents, Arthur and Althea Bell, not only dedicated and enthusiastic public school teachers in Pontiac, Michigan, but also active artists themselves, who inspired my interest in art and encouraged my early collecting of prints;

My wife, Stirling, a fellow art collector, who encourages my support of local printmakers to the point of designing additions to our house for the curating, storing and displaying of our print collection;

My son Devin, himself an excellent and avid etcher, who developed the logo for the Bell Tower Editions;

Frances Lujan and my son Cayley Bell for technical photographic assistance;

The librarians of the New Mexico Museum of Fine Arts, Phyllis Cohen and Mary Jebsen, who graciously made available to me their file collection of Santa Fe artists;

The Santa Fe artist Zara Kriegstein, who introduced me to the museum curator who became my co-author in the Santa Fe Printmakers Series;

Mark Diederichsen, whose graphic design and aesthetic talents, coupled with the organization of a myriad of details, brought this book together.

— Robert Bell

FIFTEEN SANTA FE ARTISTS:
A REFINED REVOLUTION

by James Mann

Curator-at-Large
Las Vegas Art Museum

The conception and administration of this exhibition began with a letter to galleries and visual-arts institutions in Santa Fe, which conveyed the following request:

The critical viewpoint for the exhibition is given in the six-point rationale appended to this letter. The aesthetic thus set forth is non-prescriptive in its scope. It encourages recognizable imagery of any sort or degree, but does not exclude abstraction of sufficiently complex and innovative composition. The Las Vegas Art Museum exhibition will specifically have a sympathetic eye for Santa Fe artists of excellence who have as yet no wide regional or national reputation. If you show, represent, or know of any artist(s) who you think your own interpretation of the rationale's critical outlines might plausibly include, this museum would be happy to consider them for the planned exhibition.

EXHIBITION RATIONALE:

1. **In the past century's Modern and Post-modern periods, visual art at the highest cultural level went through an analytically reasoned process of progressively dismantling the former artistic tradition piece by piece, until its reductive direction had systematically discarded every trace of the tradition's former resources of technique and content.**

2. **Advanced visual art in the twentieth century thus fully overthrew centuries of prescriptive rules, and then it logically eliminated its own enduring presence, through Conceptual Art, Installation and Performance Art, Environmental, Land, and Ecological Art, plus any other, related, dematerialization-of-art movements.**

3. **In the twenty-first century, the most important drawing, painting, and sculpture will inevitably engage in reconstituting visual art itself, in original ways.**

4. **These innovations will unavoidably employ diverse elements both of the pre-modern tradition and of the lessons resulting from the nineteenth and twentieth centuries' successive revolutionary developments in visual art.**

5. **The Las Vegas Art Museum's interest will, therefore, lie not in the art of the era now fading into art history, but rather in the new work that transcends the productions of the recent past and consequently participates in carrying its culture into the next great age of art.**

6. The advanced art described in statements 3 and 4 incorporates material from popular art and culture, as well as from the artistic traditions of other cultures, as part of its fundamental nature in utilizing all possible and available resources for its own technical and expressive devices and intentions.

Responses to this inquiry were few, and these were not promising. In response to receiving a subsequent request to elaborate concretely upon the stated rationale, the following statement was issued:

No preference will be given to Southwestern imagery, whether of figural or abstract motif. What is sought is clear originality in resurrecting visual art from its Post-modern grave. Abstraction should be complicated rather than Minimalist. Figuration should be innovatively fresh, with no degree of realistic pictorial detail, or lack thereof, either desired or stipulated. Any multiplicity of styles, or combination of figural and abstract elements, is highly respected. Artists who have as yet no reputation at all are preferable to those with larger reputations. The exhibition aims to be ground-breaking, as opposed to what is familiar or predictable. It will show not what is typical, but quite the contrary. It will deliberately frustrate, and if possible disturb and otherwise chagrin, ordinary expectations of what Santa Fe art is today. Aside from these generalizations, the only basic requirement is that the artist live in Santa Fe or its near environs and surrounding settlements.

In retrospect, now that the exhibition has become a reality, the immediately foregoing statement perhaps may be taken as representing an unattainable ideal. At any rate, it was the pole star being aimed at by the proposed exhibition. The reader and the viewer may now impartially judge how near to the stated ambition the actual exhibition managed to reach. The most thoughtful response, from among the recipients of the original inquiry sent out, may paradoxically also have missed the mark of what was hoped for by the widest margin (although the chorus of silence that the inquiry met on the whole was the most dismaying response). This letter named half a dozen artists and parenthetically summarized the nature of their particular work. Some of these leads were investigated but proved disappointing. In the main, work referred to by those brief descriptions given by the respondent could be quickly assigned to one or another moribund branch of the art of the recent past referred to in statement 5 above.

"Materiality of paint itself," for example, means Action Painting, or Gestural or Color-field abstraction, or some variant or blend of these. "Use of graffiti-like imagery": Graffiti Art is a late, sub-variety of Pop Art, which was a great but pre-dematerialization movement. "Art-brut inspired, very raw," when actually viewed, proved to be too raw to participate in the reconstitution of visual art, and belongs instead to painting's now-dead reductive, anti-technique deconstruction. As descriptive or identifying labels, "encaustic abstraction" and "conceptual" disqualified those two respective artists for this exhibition, by virtue of the very denotations of the terms employed. "Abstraction but also found paintings with the addition of painted elements" belongs to the past, when "found" art was a telling and valuable assault upon tradition, but it does not belong to the future. Not to the radically innovative reincarnation of the art of painting from the cold, wind-scattered ashes of its own late, successfully completed, analytic dismantlement.

Given the rhetoric of the previous sentence, it is perhaps apparent that the sensibility selecting the fifteen artists for this exhibition, with no consideration of any sort paid to their social group identities, made the choices from a particular perspective. At this juncture, therefore, the critical argument supporting the exhibition's intellectual coherence should not proceed further without a clear exposition of that viewpoint. The above exhibition rationale's six numbered statements outline the fundamental matter. The discourse hereafter following these prefatory remarks fleshes out this framework with more detail and thoroughness, by means of both critical theory and a critique of art history essential thereto. Since the argument is newly developed, it must receive here a fairly full, if disproportionate, treatment. To do less would be to unduly diminish the discourse's disestablishmentarian nature and purpose.

The argument's relevance to the present exhibition is absolute. The selection of these fifteen artists' work, as belonging to the most advanced art of their day, requires a new and determined, anti-establishment rationale. The most advanced artists of today are those who are reconstituting the various artistic disciplines from the ruins of the late-dismantlement, deconstructive Post-modern period. Theirs is an art which, among other intentions and achievement, recovers in unlimited ways the technical and expressive resources that were systematically stripped away and abandoned, beginning in the nineteenth, and accelerating over the course of the twentieth century.

The dismantlement process reached a virtual North Pole toward the end of the twentieth century, a pole representing complete artistic impoverishment. The only possible forward motion and direction from that pole now, upon any vector, returns south, via latitudes previously passed through on the way north to the pole. Art returns through these regions with altered eyesight, a point of view unalterably changed forever by the ordeal of the polar journey. The fact that any of this new art will resemble some older art is both inevitable and inconsequential. The situation could not be otherwise. For example, one cannot recover figuration innovatively without, in fact, using figuration. Profound innovation, not superficially familiar form or style, is the key to the most advanced new art. To adequately assess its real innovations requires insight of an engaged and searching sort. It would be a mistake of artistic judgement to expect such perception and evaluation to be quick, easy, or painless.

<p style="text-align:center">* * * * * *</p>

In the visual arts of our present civilization, in the culture we simultaneously both inhabit and create, there have lately been, and still are, an apparently bewildering welter of movements in contemporary high art that are all in operation at once. These include: Conceptual,[1] Installation, Performance, Environmental, Land, Ecological, Site-Specific, Appropriation, and Minimal Art; more late abstraction of various sorts; the final stages of Pop Art (e.g., Photo-realism, Graffiti); other miscellanea such as Video Art; and finally that small portion of recent art, such as the work of the fifteen artists included in the present exhibition, which actually supersedes the overall deconstructive Post-modernism to which all the other movements just mentioned belong. Promoters and proponents of so-called aesthetic pluralism claim that all these different kinds of current art are equal participants on the playing field of high culture. But they could not be more mistaken.

Considering how recently Post-modernism,[2] the final historical phase of the analytic dismantlement of the artistic tradition, was completed, it ought not be surprising that so many different manifestations of its completion, each one a mode of art with outmoded high-cultural intent, should be produced contemporaneously with the still relatively small body of new art, including that of these fifteen Santa Fe artists, which actually transcends Post-modernism. This new art coexists chronologically with these other movements, but it is wholly unrelated to them in terms of both cultural epoch and actual practice. The community of high culture never moves forward en masse with the most advanced innovators: only exceptional sensibilities do this. Yet it is a contradiction in terms for there to be more than one true artistic vanguard operating at the same time. The notion of pluralism in this context is merely a cop-out: an admission of failure in being able to isolate and correctly evaluate the initial, identifiable segment of today's art which is truly innovative, and which, unlike all the rest of today's artistic output, consequently belongs to the future of visual art at the highest cultural level.

Moreover, artistic pluralism is really a misnomer, because in the end, all the miscellaneous Post-modern movements, coexisting with the new art that clearly succeeds Post-modernism, belong to the single overall aesthetic of late deconstruction (or analytic dismantlement). They are simply different modes of manifesting the same aesthetic. The intellectual bankruptcy of the pluralist position is perfectly rendered in this passage by Arthur Danto in a 1984 essay, "The End of Art": "As Marx might say, you can be an abstractionist in the morning, a photorealist in the afternoon, a minimal minimalist in the evening. The age of pluralism is upon us. It does not matter any longer what you do, which is what pluralism means. When one direction is as good as another direction, there is no concept of direction any longer to apply." Is one direction really as good as another? Or does this statement merely expose the inability to perceive a larger pattern behind the above-mentioned confusing appearance of chaos in contemporary art? A better model for understanding the dilemma of the serious artist today is a critique of art history, and of its present, puzzling juncture, along the following lines.

Before 1800 and the dawn of Romanticism, all fine art was synthesizing in its fundamental nature. It is true that artists, as well writers, composers, and other thinkers before Romanticism generated a clearly observable development or evolution in high culture. It is also true that this development took place in response to an ongoing philosophical and aesthetic assessment of existing culture and perceivable reality. Nevertheless, throughout cultural history before 1800, artists and other thinkers always implicitly accepted and assumed that the overall culture they lived in was valid. If they found fault in some aspect or condition of it, they sought to ameliorate this imperfection, through the corrective of their own new work, and thus to improve the culture as a whole. However, they never questioned the basic validity and ultimate value of the culture itself. They automatically assumed that if an element in the culture's self-explanations were found to be in error, it could be satisfactorily corrected. That is, their corrective adjustments always had a view and an aspiration toward an ultimate, satisfactory synthesis.

One can find this fundamental cultural certitude perfectly expressed, and indeed succinctly summed up, by the English poet Alexander Pope in a famous passage from his long poem Essay on Man (1733-34):

> All nature is but art, unknown to thee;
> All chance, direction which thou canst not see;
> All discord, harmony not understood;
> All partial evil, universal good;
> And spite of pride, in erring reason's spite,
> One truth is clear, Whatever is, is right.

Whatever is, is right. That was then: the eighteenth century, to be precise, under the paradigm of synthesis. Even an artist as revolutionary, as radically original and socially fractious, if not literally iconoclastic, as Caravaggio (1573-1610), while he almost singlehandedly overthrew Mannerism with what at the time were shockingly realistic human portrayals, and while he also lived a turbulently unruly life, is nevertheless seen in his work to have hewn doctrinally to the basic party line of church and state, receiving the patronage of both ecclesiastic and aristocratic society. He even sought and received, briefly if disastrously, admission to the Knights of Malta.

After 1800, on the other hand, in diametrical contrast to the synthesizing endeavor of all pre-Romantic art and artists, the Romantic artist found the culture itself no longer sufficiently viable. This is an individual for whom the accepted explanations that validate the culture have collapsed: to whom they no longer make sufficient sense. To remedy such non-conforming alienation, therefore, this artist/thinker has to invent a new explanation that makes better sense of the surrounding culture. In so doing this artist dismantles and destroys the existing, standard, approved explanation of the culture's congruity and internal consistency. In other words, this individual rejects as artistically and/or philosophically unsatisfactory the currently held view of the culture's validity, and so attempts to overcome the resulting personal disillusionment by creating a new rationale, whose purpose is to eliminate the incoherence perceived in the culture's self-justification. Again, this incoherence is what caused within this artist the response of cultural rejection and alienation in the first place. Or else the individual sees the ultimate futility of all explanations that seek to find unconflicting coherence within the culture, and instead creates work that amounts to an anti-explanation, a refusal to find redemptive value in the culture.

Either way, this artist/thinker would seek to transcend the current state of culture by denying, by overthrowing its cultural norms. Either way, the artist was deliberately demolishing the received high-cultural notions of the time. The true Romantic had to create redeeming value out of a lifetime of personal experience, finding it impossible to rely upon the culture to create such value in a satisfactory manner or degree. Therefore, the cultural history of the past two centuries was an uninterrupted continuum of failed aesthetic and philosophical explanations of cultural value, these being constantly destroyed and replaced by newly innovated explanations or anti-explanations. And it is the tension between these two opposite means of cultural transcendence (new explanation vs. anti-explanation) that is responsible for the rapid succession of artistic styles and the extraordinary, self-renewing

creative vitality of the fine arts throughout the past two hundred years. Repeatedly during that long period, by analytically demonstrating the essential failure of the current state of culture and its ruling set of explanations, the serious artist and/or thinker effectively destroyed that particular version of culture. This unceasing process of the inevitable destruction of explanatory systems which are born to fail, just as men are born to lose, might be called the perpetual motion machine of the last two centuries of intellectual and fine-arts history.

It was out of the spectacular failure of synthesizing, eighteenth-century Enlightenment European culture, by virtue of the murderous course of the French Revolution and the warmongering Napoleonic military dictatorship, that Romanticism, and subsequent Romantic culture, i.e., all subsequent high culture, were born. The problematic philosophical divergence, if not antithesis, between nature and reason, is what the ideologues of the French Revolution attempted to reconcile, to synthesize into a new society, a new phase of culture, a new humanity. Another English poet, William Wordsworth, was so devastated by the events in France that he interpretationally disengaged himself from the world altogether, in effect, for a year and a half, suppressing his traumatic stress exclusively through the study of mathematics. Then he re-emerged in his alienation as a Romantic poet seeking to negate and transcend the culture that had so thoroughly betrayed his faith in it. Like every Romantic artist after him, he sought to destroy those inadequate validating explanations of his culture which he could no longer believe in.

The subsequent work of all truly original artists in the nineteenth and twentieth centuries, since the first publication of Wordsworth's and Coleridge's Lyrical Ballads in 1798, has therefore been culturally vandalistic. The fact that this vandalism is symbolic, that it is exercised not against physical property but against artistic and philosophical ideas, does not make its destructive intent any the less real, nor the term "vandalism" any less appropriate to describe it. In fact the second entry in the Oxford English Dictionary for the word "vandalism," occurring in 1800 (the first citation is from 1798), reads as follows: "W. Taylor in Monthly Mag. VIII. 684[:] 'The writers, who bring against certain philosophic innovationists a clamorous charge of Vandalism.'" Accordingly, "vandalism" in English has been associated with innovation at the highest cultural level since the earliest days of its usage, the earliest days of Romantic culture.

The cultural history for the intervening two centuries has been one of the progressive, analytically reasoned and executed dismantling of Euro-American high culture, through continual cultural vandalism, until in our time this systematic demolition finally has been completed. Of course, it is humanly impossible to transcend one's entire culture at once: that extreme would mean giving up the language one speaks, the monetary system, adherence to traffic laws, indoor plumbing, and so on. Rather the artist/thinker transcends that portion of the culture which he is able to, that which the individual finds most immediately, intolerably unsatisfactory. The ensuing effort is not to cure the culture, not to correct its error in order to nurse it toward a theoretical wholeness taken on faith, as was the intent of artists before Romanticism arose. Instead the individual now rejects completely what is found unacceptable, in order to cause its downfall, and to rebuild in the resulting void on one's own terms. Certain existing cultural assumptions are found invalid, and

consequently the artist must find, out of personal resources, an original way to impart value to the world. Bit by bit over two centuries, the whole high-cultural superstructure of our civilization's artistic tradition–the set of explanations that justified the norms and forms of the tradition before the rise of Romanticism–was called into question and analytically dismantled as inadequate and unsatisfactory.[3]

There is a brief remission here to double back and summarize the directly preceding argument defining the nature and effect of two centuries of successful analytic dismantlement. The most advanced artist/thinker found the enveloping culture critically flawed and sought to create work that would transcend that culture, thereby overcoming its pitfalls and allowing the innovator to avoid being the victim of an unsatisfactory explanatory condition or cultural set of circumstances. By analytically dissecting in one's work the prevailing failure of the current culture, such an artist invalidated that dysfunctional version of culture, and accordingly replaced it: either with an anti-explanation, or with a new, more adequate version of culture, which itself would then eventually meet the same fate. The Romantic artist sought to destroy the high-cultural status quo and if possible to replace it with more adequate intellectual and artistic models. A brief example of this dismantling impulse and concomitant usurping enterprise is contained in the following words by Kandinsky from 1912: "We must destroy the soulless, materialistic life of the 19th century," and "we must build the life of the soul and the spirit of the 20th century."

Like an audio tape accelerating to its end, the now intellectually exhausted, obsolete aesthetic of deconstructive Post-modernism eventually completed the twentieth century's gathering, unstoppable momentum in gradually but systematically dismantling all the fine arts, ultimately yielding an extreme or total divestiture of the former expressive and technical resources of the several artistic disciplines. By the mid-twentieth century, painting, for example, became mainly (or merely) an increasingly stripped-down response to immediately previous painting. Reduction became inevitable in the analytic breakdown process, and artists at the innovative frontier could do no more than respond narrowly to the previous development in analytic dismantlement itself, having been left no other allowable imagistic raw material to work with. Once content had been discarded, there was little left to dismantle but technique. Yet the dismantlement had to be carried out to the bitter end, and somebody had to do it.

Before 1800, synthesis; since 1800, analysis. For purposes of the argument further ensuing here, which is complicated, a shorthand way to think about, or a simplified definition of, these two terms is hereby offered. Synthesis refers to all those artistic periods and procedures whose resulting creations preceded the paradigm shift to Romantic culture around the year 1800. Analysis refers to all those artistic works created at the highest cultural level during the historical epoch beginning around 1800, and lasting to around the close of the twentieth century. Put even more briefly, synthesis equals all high art made in Eurocentric culture before 1800, and analysis equals all such art made between 1800 and the complete exhaustion of its usefulness and accomplishments, around the end of the twentieth century.

After the total, reductive deconstruction of art, which got obviously underway in painting by 1850, and which was manifestly invincible throughout the course of the twentieth century, analysis itself has run out of material to work with, and that leaves art in its true, present situation or condition. There is nothing left to dismantle of the former, thousand-year tradition, together with its prescriptive and authoritarian foundation. Since the various fine arts have been analytically dismantled, completely picked apart and broken down, therefore, the important and indeed inevitable work now confronting serious innovators is to pick up the junked pieces and put these art forms back together again in unlimited new ways. Analytic dismantlement and its twin, revolutionary Romanticism, cannot continue operating with no vestige of the former tradition left to pick apart, examine, and transcend. Accordingly, these twin engines of culture have themselves broken down, and thus have come to an end. But the priceless legacy of Romantic culture bequeathed to today's art lies in the incorporation of its basic pattern or procedure–analytic dismantlement and cultural transcendence–into the notion and practice of the work of art as deliberate construct. This notion and its practice now succeed analysis as the inevitable, next aesthetic paradigm, for the art of the new century just begun.

The future of all the fine arts in transcending Post-modernism, in moving beyond it, encourages artists to explore all levels of the surrounding culture for their innovative purposes. Because of the essential legacy of Pop Art, which dispensed with the authoritarian, artificial hierarchy heretofore separating high from popular art, artists of the greatest cultural ambition can now adequately reconstitute the fine arts only by using the available expressive and technical resources found in all levels of culture. In today's diverse and chaotic culture, the most competent and valuable art will be that which makes the fullest and richest use of the entire range of culture at all levels, both past and present. Furthermore, it is inevitable that if an artist is to avoid merely perpetuating the stripped-down, fully deconstructed, Post-modern aesthetic, which has now reductively dead-ended, then the most logical direction available to artists is to reclaim innovatively the lost and abandoned resources of technique and content which formerly existed in the now dismantled fine-art disciplines.

Whereas throughout the late-dismantlement period of deconstructive Post-modernism, the narrowing possibilities of art caused many painters and sculptors to abandon their artistic disciplines altogether, now the high-cultural situation is completely otherwise. By the time of the advent of Post-modernism, establishment, mainstream artists were aesthetically proscribed from responding to anything but the latest innovations of the deconstruction, of analytic dismantlement itself. Moreover, those artists today, both young and old, who have never practiced or trained in drawing, painting, or sculpting from the start, and who thus have never learned any drafting or rendering skills at all, consequently have no foundational resources to draw or rely upon. They have nothing to build an innovatively reconstitutive oeuvre upon but concept itself, which in the making of visual art is little more than an institutionalized attitude. An artist in that worldwide, advanced visual-art climate, except for an almost negligible percentage of forward-seeing heretics such as Larry Rivers (1925-2004) and Bob Thompson (1937-1966), could have no compass, sweep, or reach into the great realms of imagery and the imagination which art had once

claimed for itself. Instead, the artist was imprisoned within that continually self-diminishing, reductive aesthetic of late- and then Post-modernism.

In the new art that supersedes Post-modernism, however, artists can now acknowledge and incorporate, in their own work, the innovations of the twentieth century's highly deconstructive process, as well as freely access all the art history preceding that Modern and Post-modern century. Artists are also now freer than ever before to respond to artistic traditions other than their own. This will be simply a natural result of the new advanced art's aesthetic attitude of non-hierarchically exploring the world's cultural cornucopia, with no exclusive boundary between the different levels of culture, albeit with high-cultural complexity of awareness and intent. Advanced artists are now, for the first time in cultural history, liberated from the prescriptions, proscriptions, and authoritarian positions of the past, of the former tradition. They can now freely explore and use the widest possible range of sources and resources, of both technique and content, in order to create highly ambitious works of art that grapple innovatively with beauty, meaning, and value in the contemporary world of this new century.

Any advanced, superior execution of art hereafter will generate works of fine art that are themselves ad hoc constructs, partially combining both synthesis and analysis. Such a construct is an artistic solution, to real yet temporary intellectual problems, using not only salvaged resources from outmoded synthesis and analysis, but in addition all the possible human resources of art worldwide. The Eurocentric development and history of art have inevitably proven that synthesis and analysis both were ultimately dead ends. Yet the new artistic construct, the most advanced new work of art, can use them both as rich resources. The new construct can thus involve both synthesis and analysis in its own production, making plentiful, selective use of their centuries of fine-arts history. Thereby the innovative new work of art will constitute a whole new vision of the two former paradigms by way of its own, most highly advanced creation.

To reiterate, an advanced visual artist now is not limited to using the resources of synthesis and analysis alone, but can use all the available human resources for art, all the art history of other cultures, as well as resources from within all levels of the artist's own culture. The new aesthetic is non-hierarchical, in that it abolishes the former partitioning exclusivity between cultural levels. It is also non-prescriptive, with the result that this is the first non-authoritarian aesthetic in world cultural history. Whatever the most advanced artists now create in the way of a construct, it will contain elements of the analysis mode which are able to neutralize any elements of the synthesis mode that may be employed in a given work or body of work. Furthermore, the construct's problem-solving effectiveness can be abandoned at any time. No matter how brilliant a construct's creation may be, how serviceable its tailor-made trouble-shooting and overcoming spirit, in the long run the effectiveness of its temporary solution will not be stable.

Analysis hereafter will always involve synthesis, or vice versa, in the creation of any construct, and the two modes remain powerful resources. Thus it bears repeating that the priceless legacy of Romantic culture bequeathed to today's art lies in the incorporation of its basic pattern or procedure—analytic dismantlement and cultural transcendence—into the

notion and practice of the work of art as deliberate construct. This notion and its practice now succeed analysis as the inevitable, next aesthetic paradigm, for the art of the new century just begun. The artistic construct is an instrument, belonging to a philosophy of instrumentality. And a construct's instrumental effectiveness, from a pragmatic point of view, can be taken only so far, after which it will inevitably be invalidated.

The culture we live in is essentially chaotic and incoherent, more so now than ever before, because it is richer and can tolerate more diversity. In today's diverse culture, therefore, in which the previous high-cultural explanations have all been analytically negated, art must now be quintessentially pragmatic. It can no longer be programmatic and conform to organized, absolutist principles, since these have been systematically eliminated by two centuries of analytic dismantlement. As a philosophical system, Pragmatism is anti-explanatory. So was the dominant type of Romantic cultural transcendence, as opposed to the type which attempts to devise a better, higher, more adequate, substitute explanation. As far as our cultural history has come, the human mind is no longer going to be anchored to any one particular vision. Therefore, after a new artistic construct's intellectual problems are solved by its birth or origination, that work or body of work's particular solution will eventually disintegrate into a whole new set of problems. Then its positive effectiveness for future work, by the same artist or by others, will finally fail. In the meantime, nevertheless, it will have brought about new conditions of perceptual experience, and that is the particular construct's ultimate value.

The construct artist builds an alternate reality through the new artwork. Other members of the culture can ratify and follow the alternative thus offered, but due to the completed and definitive obsolescence of both synthesis and analysis, the post-analytic artist henceforward cannot presume to impose upon others the ad hoc construct, the alternate reality created by the new construct-artwork. Others within the culture must impose that upon themselves, if they find the new construct's alternate reality to be provisionally satisfactory, and as a result choose to exercise and subscribe to such self-imposition. Then for as long as a given construct's solution is considered adequate, its vision can penetrate and to some extent reorganize the artistic and wider culture from which it springs.

* * * * * *

Recognizable imagery is most plentiful in this exhibition called Fifteen Santa Fe Artists, although some abstraction is included. Highly non-traditional landscapes are present, along with plentiful subjects employing the human figure. Among other qualities and content, there are political and social satire, pop-culture and folk imagery, painted desert, the influence of Post-impressionism, Expressionism, Cubism, Surrealism, Baroque, Neoclassicism, Realism, Metaphysical Art, Divisionism, Macchiaiolism, Color-field painting, Gestural abstraction, and many other historical movements. There are old-master anachronism, art-historical quotation and distortion, literary allusion, the grotesque, mythology, cultural commentary. Some of the artists paint in a highly finished, detailed figural manner, but the drafting and rendering of others is as loose as possible. Some of the artists demonstrate a consistent manner and style, some a variety of both simultaneous and evolving styles, and others a highly disparate stylistic discontinuity. Some make

abundant reference to art history, some none at all. Some confront and refer to popular culture, others ignore it. Some depict contemporary people, others employ figures in a deliberately archaic or neoclassical manner. Mythology appears with some artists, photography-fed celebrity culture in another. This exhibition aims to be ground-breaking, the opposite of what is familiar or predictable. It is not meant to be a representative survey of art being made in Santa Fe today, but rather to frustrate ordinary expectations of what "Santa Fe" art is at the present time. Innovative originality, contrary to what is typical, is the salient quality which the selected artists' work possesses.

All of these fifteen artists' oeuvres exemplify in one way or another—and some of the artists in several ways at once—the notion of the work of art as deliberate construct, this being the current innovative frontier in the visual art of our contemporary culture. All their work belongs to the same new artistic threshold, which rests upon or strides over and across nothing less than an epochal shift of tectonic plates in cultural and art history. This shift is not proportionate to such a comparatively minor degree of change as, for example, the progress from Impressionism to Post-impressionism, or the shading of Cubism into Futurism and Vorticism, then into Simultaneism, Rayonism, and Constructivism, then into Neoplasticism and . . . so on. On the contrary, the current situation represents the biggest shift in art, in all the fine arts, to occur in the last two hundred years. Even so, this shift into a new art beyond Post-modernism is not necessarily any easier to recognize than Romanticism was when it first appeared in 1798; or than Modernism was in 1865, 1905, 1908, or any rival date assigned to its beginning; or than Post-modernism itself was in 1968, or 1963, or . . . 1957? To illustrate the lag between innovative new visual art's emergence and its being accurately understood, even by cognoscenti, one needs only to recall that in the 1920s, some critics were still writing about the work of Matisse, Picasso, and Brancusi as little more than concrete evidence of sexual perversion.

Many of these fifteen Santa Fe artists essentially practice one style only. But such an artist may leap from a commonplace subject of mass-market decor or consumer product to a mythological event colliding into, or existing placidly beside, the contemporary scene. Or there may be incongruous juxtapositions of chronological time and cultural space. There may be irrational, mystically joined concatenations of mundane imagery, or of time-honored super-subjects, spiritual, religious, mythological. There may be wide-open spaces, vast vistas regionally referential; or deep-vision history scenes looking randomly blended in a time machine; or angst-ridden confrontations of historically disparate personages, hauntings of the present by the most sublime artistic beauties of the past, background action invading foreground world and illuminating or darkening life today. Some of the artists in their work both celebrate and mock the culture they live in, horror and joy both given their due. Some of this work is visionary and frighteningly apocalyptic, some peacefully ethereal or lacking in any real or implied human figural, participating presence.

A few of these artists have evolved over time either through the progression of a limited range of style and subject matter, or through a wider sustained stylistic progression, or through a wilder sequence of radically different styles. Such painters well exemplify the work of art as deliberate construct, running out of gas, so to speak, and then filling up next time with another brand or a higher octane. And at least one of the artists has repeatedly

shifted gears among a number of severely different modes, with one work's new construct then being unsentimentally dumped for another work's wholly different construct, according to the artist's immediate interest, need, or desire for change, the most powerful artistically metamorphic cause of all.

Fifteen, the number of artists in this exhibition, was simply the cut-off point beyond which the Las Vegas Art Museum's galleries could accommodate no additional work. There is no separate discussion engaged in here of each of the fifteen individual artists' work, because their distinct endeavors belong to and constitute one overall direction, and that is why their work was chosen for inclusion. Theirs is a joint revolution taking place upon the current innovative frontier of the visual arts of our contemporary culture. As far as this curator is concerned, these artists have all created themselves both equal and self-evident, and what they share in epochally new terms is far more important than the individual distinctions that could be pointed out among their unique bodies of work. In any case, many such distinctions are obvious from simply viewing the work, with an appreciation for its revolutionary stature, its standing at the highest cultural level now. Neither is biographical information offered here. This deliberate and calculated omission allows the work of each artist to be assessed on its own strengths. It ensures that the pleased, outraged, or indifferent viewer's objective judgement is not influenced or otherwise corrupted by the artist's exhibition history, the academic degrees the artist may or may not have earned, the grants received or not received, the social background, and so on. The fifteen artists included in the exhibition range in age from their twenties to their seventies. They have resided in the Santa Fe area from as few as three years to just over seventy.

Part of the trouble some viewers will have, in recognizing the genuine innovations of the newly begun period of art history with which this exhibition is exclusively concerned, is due to the new art's unavoidably recovering artistic resources, of both technique and content, that existed before those resources were systematically discarded under analytic dismantlement. Fragments both large and small of past styles, subject matter, and artistic method, are inevitably going to reappear if visual art is ever to manage to reconstitute itself. An enterprise of that magnitude can't be accomplished otherwise. Not by pulling a rabbit out of a hat. In the new art, which leads its visual-arts culture beyond Post-modernism, all viewers will recognize familiar elements of previous art. Regardless how differently or innovatively these former elements may now be recovered and reactivated, this recognition of what is apparently familiar will undoubtedly cause in some observers the surface impression that what they're looking at is nothing new.

In painting, this new work can never have the obviously revolutionary appearance–revolutionary in their respective times–of previous movements like Cubism, Surrealism, Abstract Expressionism, Minimalism. This again is unavoidable, because part of the new art's function is innovatively to put back together, in an unlimited variety of ad hoc constructs, what those and other visual-art movements broke down, tore up, and threw away. In order to re-use it at all, what an artist recovers has to resemble, to a certain extent, what was thrown away. Therefore, discerning this new art's revolutionary nature requires more intellectual effort than does recognizing the obvious recurring novelty found in the crowded sequence of art movements

created throughout the previous epoch, from before Impressionism through Minimalism and the dematerialization of art.

Artists practicing today can at last take advantage of all the innovations of nearly two centuries of artistic experimentation brought about by analytic dismantlement, in addition to being able to exploit all of art history before that, in what has been described and defined in the present discourse as the pre-Romantic, high-cultural paradigm of synthesis. Sadly yet predictably, however, most serious artists today are either standing still at, or else just walking in circles around, the aforementioned artistic North Pole: the termination point, the dead-end of the late-dismantlement, Post-modern aesthetic. However, the most advanced artists, including these fifteen from Santa Fe, are busy reconstituting the art form in which their careers are engaged. Because these artists now have the freedom, for the first time in art history, to exploit ALL the possibilities of art, each artist can select which of these possibilities to explore in the ad hoc construct of a given work, or in a larger construct that dominates a given personal phase of artistic self-development. Like a sunbeam split by a prism, art's vision has greatly widened, and its potential component parts have been manifestly multiplied.

NOTES

1 CONCEPTUAL ART: "[A]rt giving primacy to idea over craftsmanship. . . . [M]ost art movements to emerge in the 1960s—notably BODY ART, PERFORMANCE, LAND, and MINIMAL ART—because they involve questions about the nature of art and attempt to expand its boundaries, can also be called Conceptual. Conceptual art emphasizes the elimination of art objects, or at least, in the case of EARTHWORKS, of art objects as marketable commodities. ENVIRONMENTS, which are usually temporary [as are INSTALLATIONS] and aim to heighten awareness of a site and of spatial and other relationships, are Conceptual in content. The idea and the process of execution are the 'art' and not the physical product. . . ."

—Random House Dictionary of Art and Artists

2 In the present context, the term "Post-modernism" is relegated with finality to its dominant usage in recent criticism of the several fine arts: as a general label for late deconstructive movements. The common conception of the term is substantially different: a misunderstanding caused by the word's popularization as a name for a certain period and general style of architecture. This architecture's preeminence has now decisively ended, with the rise of such architects as Gehry, Predock, Eisenman, Koolhas, Tschumi, Hadid, Isozaki, Mozuna, Hara, Takamatsu, Hasegawa, Calatrava, Viñoly, et al. Despite the generic, popular understanding of the name Post-modernism, an impression principally caused by the often eclectically composite nature of what is called Post-modern architecture, a systematic survey of the term's usage in criticism of the other fine arts reveals the expression to be employed, in overwhelming proportion, as a label for artistic phenomena strictly of the late-dismantlement, reductive sort.

In the visual arts, "Post-modernism" is quite predominantly used to encompass late reductive movements: from an uncertain point not long before Minimalism, through the latest tortured developments in the now aimlessly drifting and meandering "dematerialization of art." In poetry, the term has been applied almost exclusively to contemporary verse so stripped of technical resources that it is largely indistinguishable from common prose if read aloud. In serious music, one finds "Post-modernism" used to denote the dismantlement process completed, for example, in the random noise-music of John Cage. And so it is used in drama and dance criticism too: as a descriptive label for extremely reductive works, such as the Living Theater company's audience/cast interactive performances improvised without a script.

3 Cultural vandalism and cultural transcendence are ideas first appearing in the theory of nineteenth-century culture advanced by Morse Peckham, the author of, among other books, Man's Rage for Chaos, Beyond the Tragic Vision, Victorian Revolutionaries, Romanticism and Behavior, The Triumph of Romanticism, and Explanation and Power.

FIFTEEN SANTA FE ARTISTS

JO BASISTE

Photo by Robert Bell

Seven Cardinal Virtues

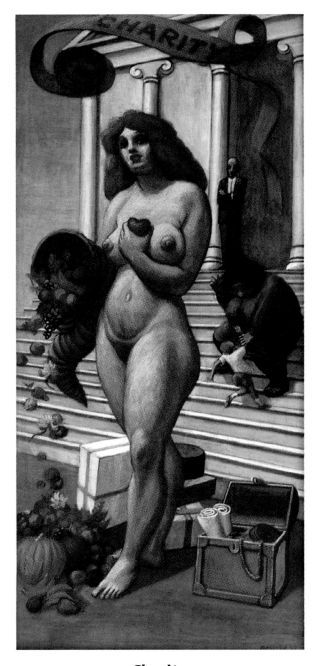

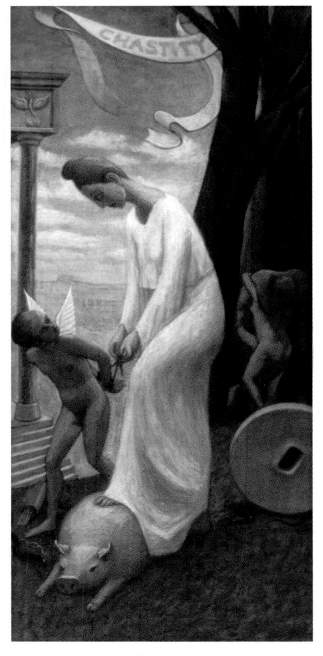

Charity

egg tempera on panel, 36 x 16 inches, 1997

Chastity

egg tempera on panel, 36 x 16 inches, 1997

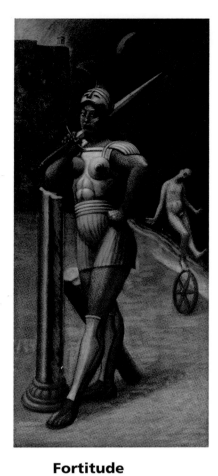

Fortitude

egg tempera on panel, 36 x 16 inches, 1997

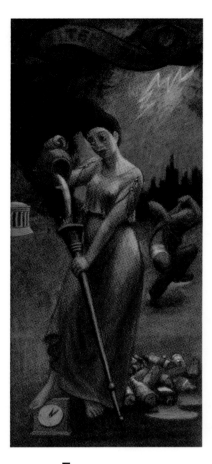

Temperance

egg tempera on panel, 36 x 16 inches, 1997

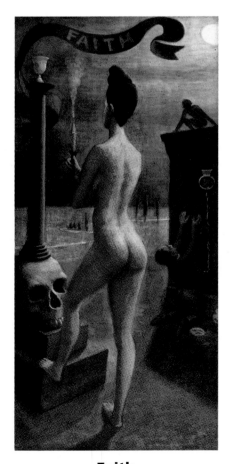

Faith

egg tempera on panel, 36 x 16 inches, 1997

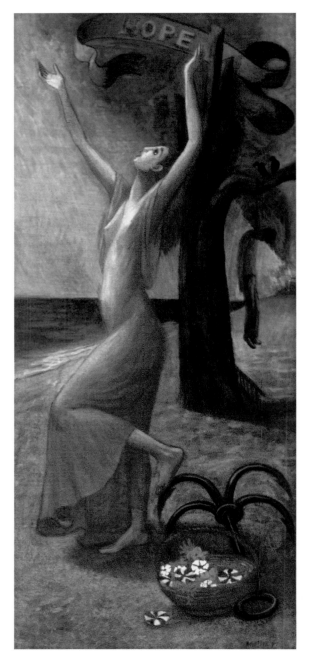

Hope

egg tempera on panel, 36 x 16 inches, 1997

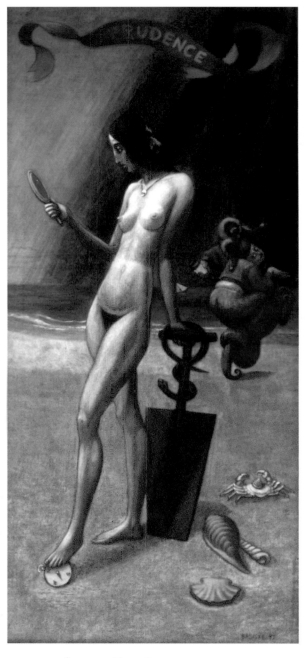

Prudence

egg tempera on panel, 36 x 16 inches, 1997

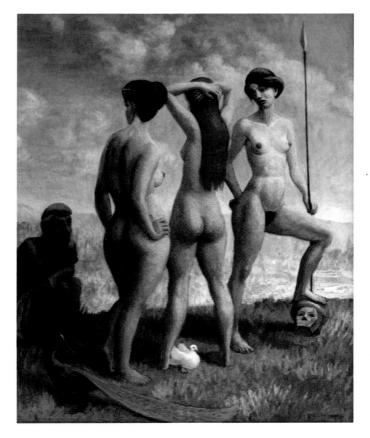

Judgement of Paris

egg tempera on panel, 30 x 24 inches, 2000

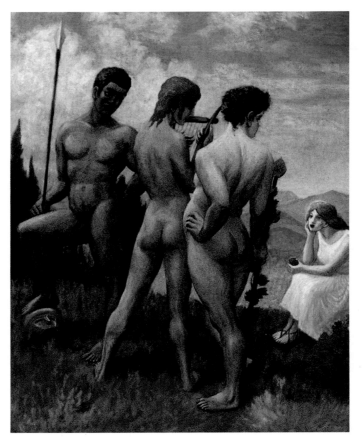

Judgement of Paris Reversed

egg tempera on panel, 30 x 24 inches, 2000

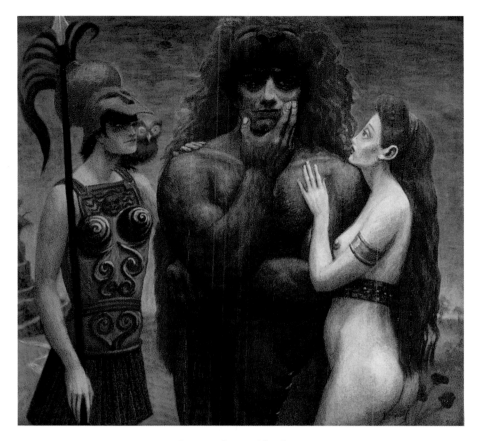

Hercules' Choice

egg tempera on panel, 24 x 26 inches, 1999

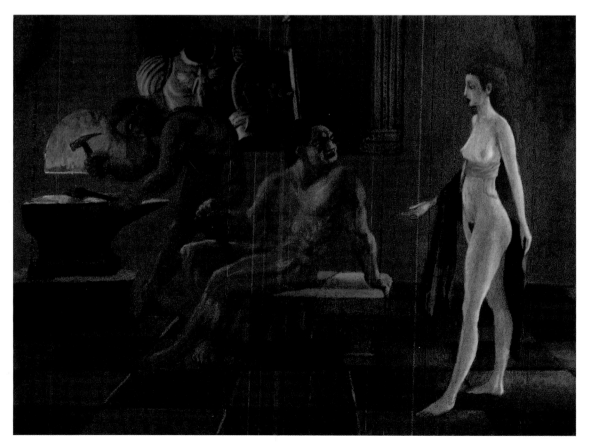

Venus Visits Vulcan

egg tempera on panel, 18 x 24 inches, 1998

DENNIS FLYNN

Photo by Robert Bell

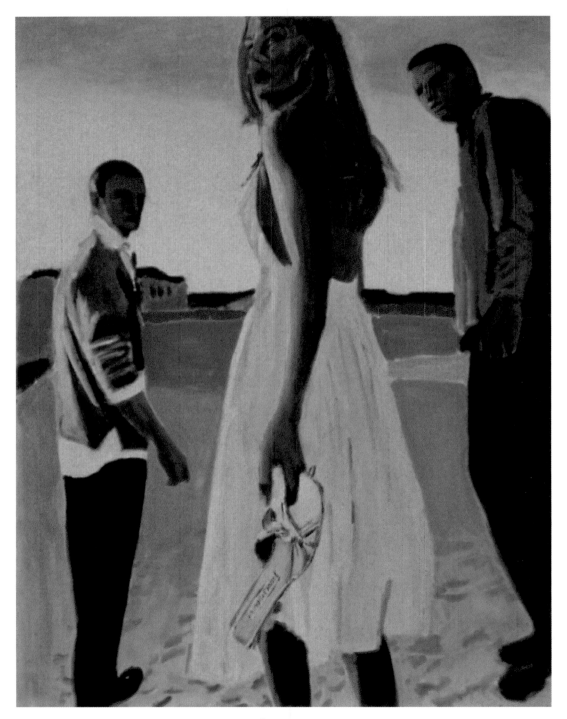

À trois

acrylic on canvas, 42.5 x 33 inches, 2001

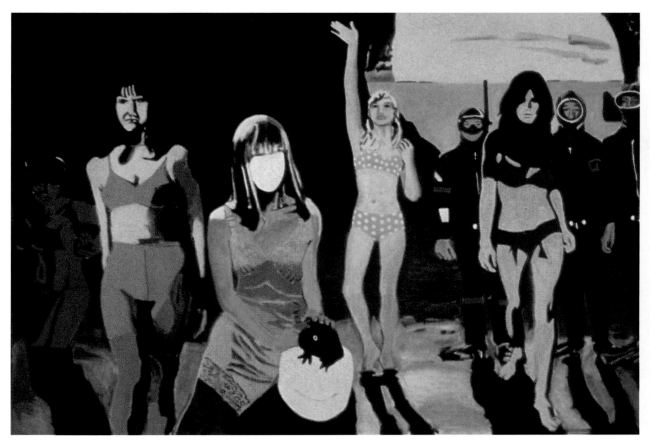

Venus

acrylic on canvas, 48 x 72 inches, 1996

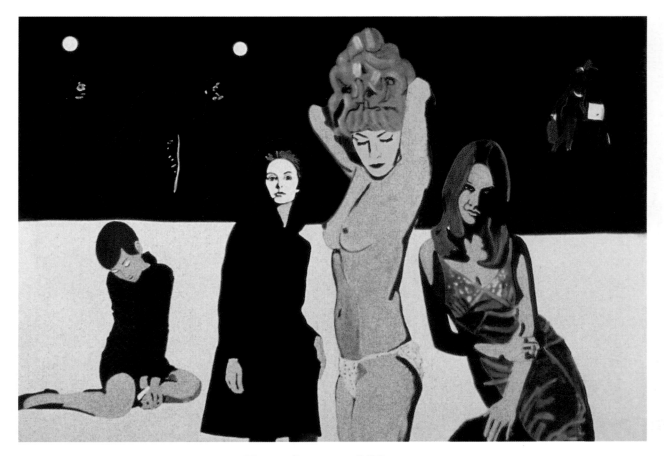

Three Stages of Women

acrylic on canvas, 48 x 72 inches, 1997

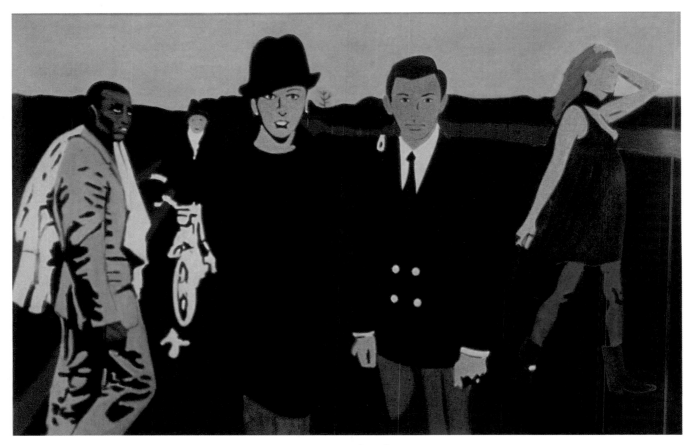

Frieze of Life

acrylic on canvas, 48 x 72 inches, 1997

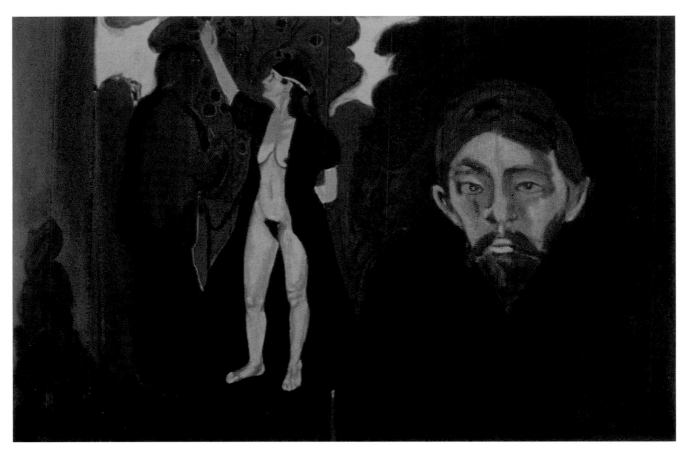

Jealousy

acrylic on canvas, 30 x 46 inches, 2000

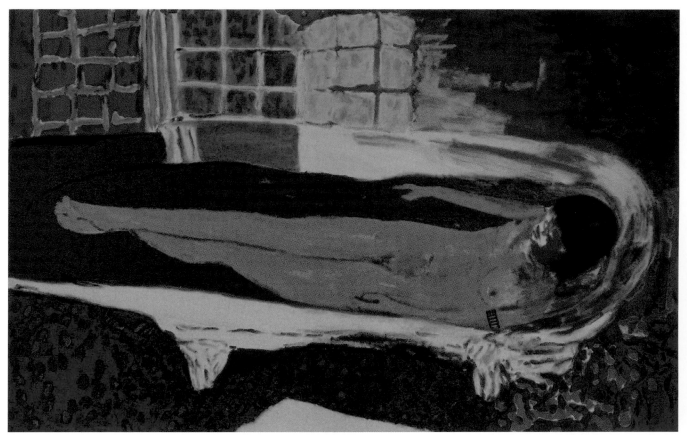

Nude in Bath

acrylic on canvas, 29 x 46 inches, date

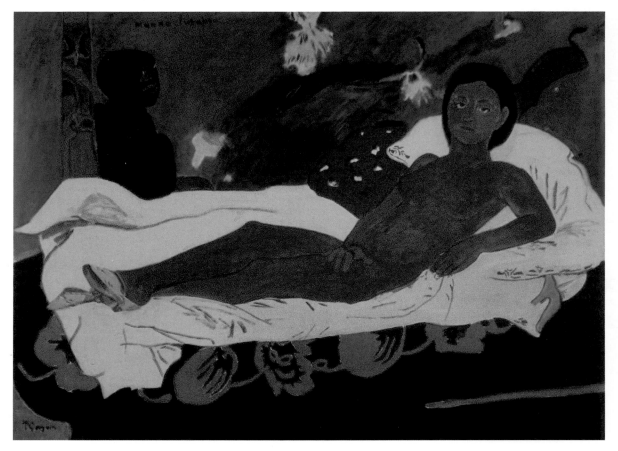

Olympia

acrylic on canvas, 34 x 46 inches, 2000

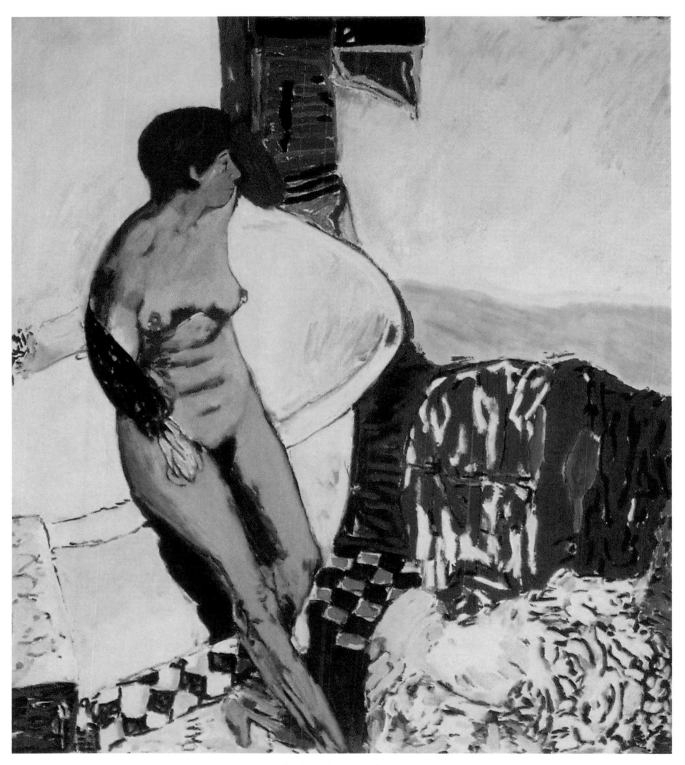

Nude in the Bathroom

acrylic on canvas, 39 x 34 inches, 2003

PAULETTE FRANKL

Photo by Robert Bell

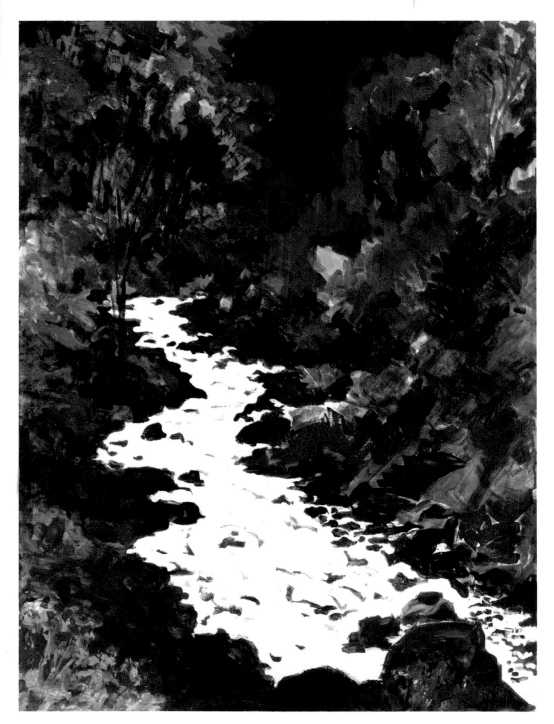

The River

acrylic on canvas, 40 x 30 inches, 2004

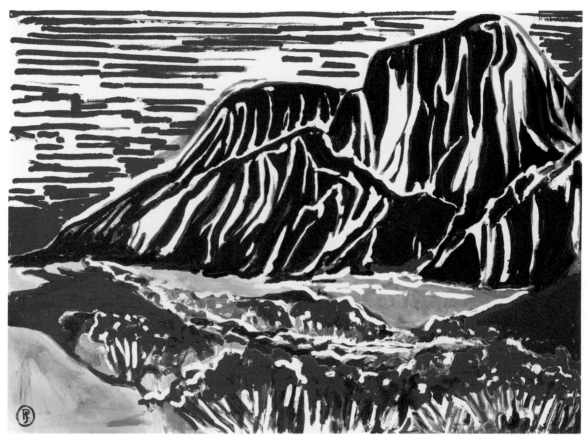

Zion I

acrylic on canvas, 30 x 40 inches, 2004

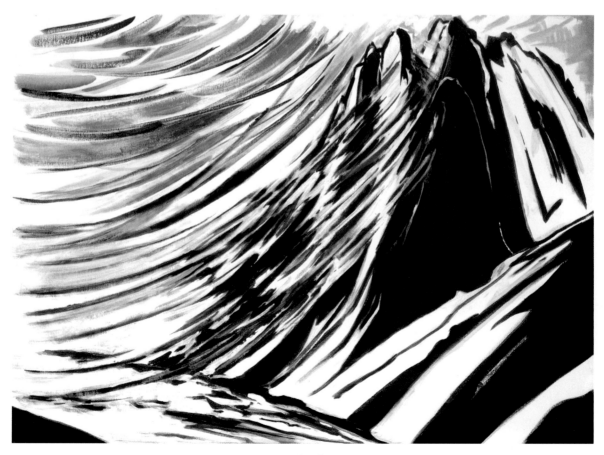

Wind

acrylic on canvas, 30 x 40 inches, 2004

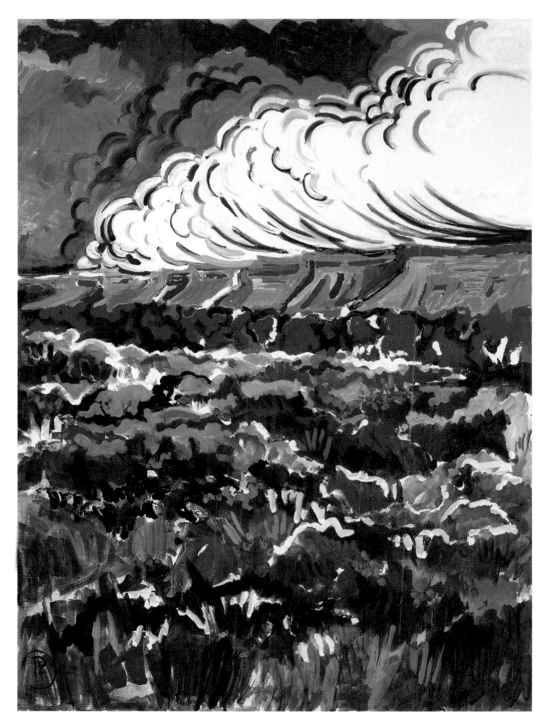

Mesas

acrylic on canvas, 40 x 30 inches, 2004

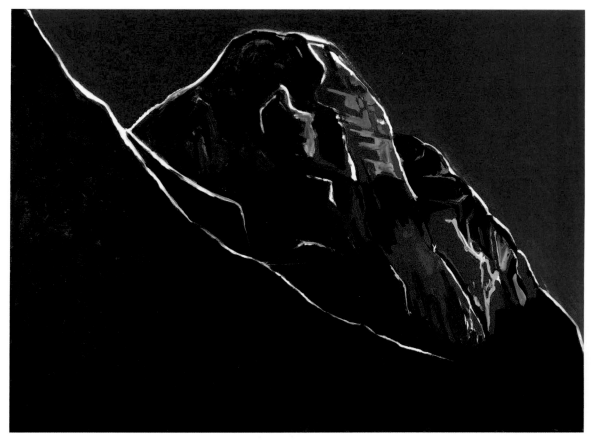

Zion II

acrylic on canvas, 30 x 40 inches, 2004

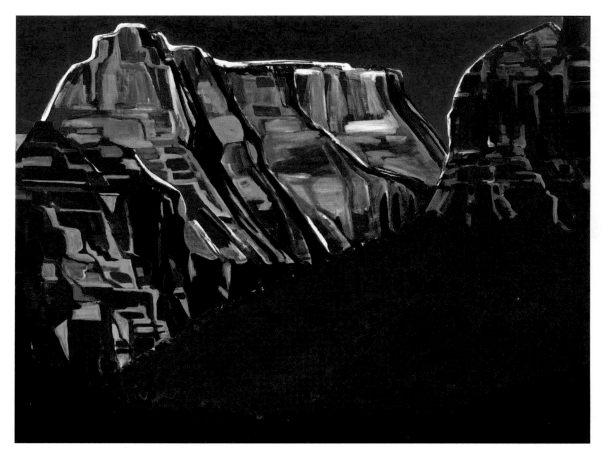

Zion III

acrylic on canvas, 30 x 40 inches, 2004

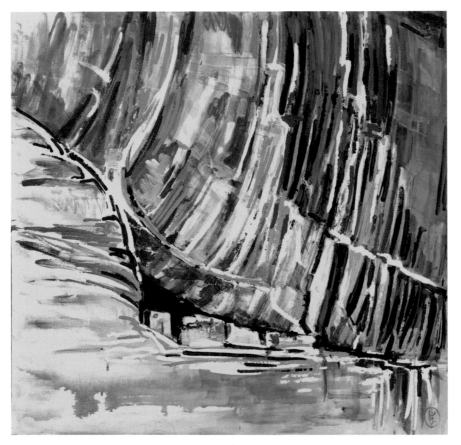

Canyon de Chelly

acrylic on canvas, 36 x 36 inches, 2004

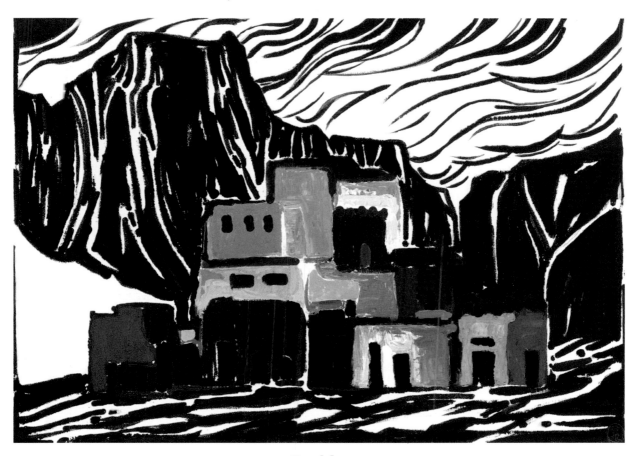

Pueblo

acrylic on canvas, 30 x 40 inches, 2004

JOEL GREENE

Photo by Robert Bell

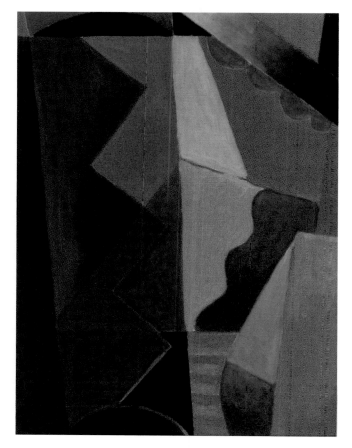

Composition

oil on panel, 16 x 12 inches, 1986

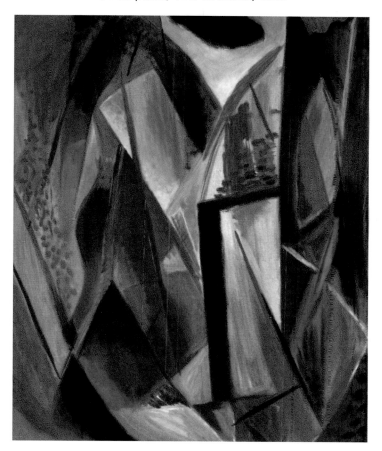

Black Cloud

oil on panel, 20 x 16 inches, 1987

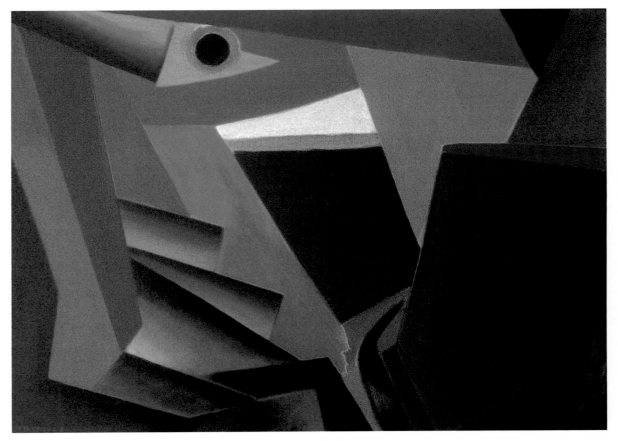

Composition

oil on panel, 17 x 24 inches, 1982

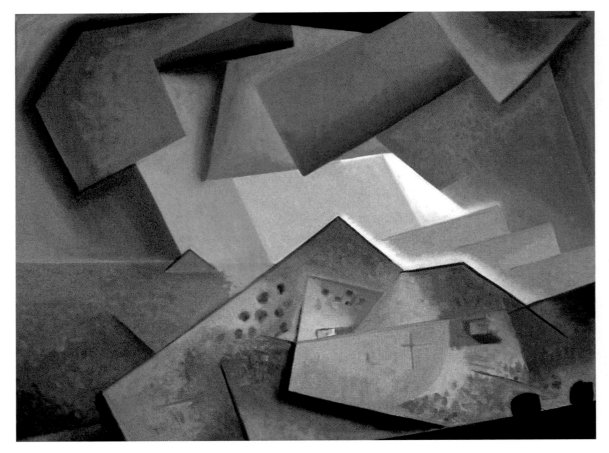

Cloud Burst

oil on linen, 22 x 30 inches, 1992

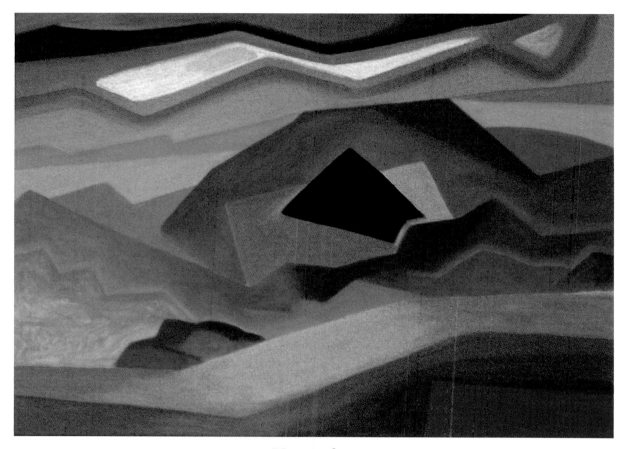

Mountains

oil on panel, 17 x 24 inches, 1992

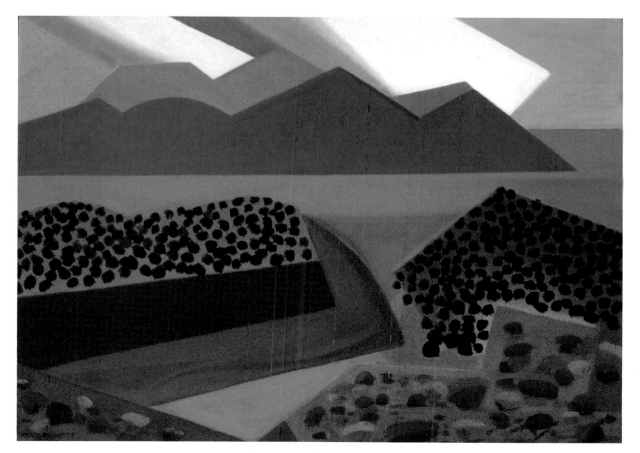

Plains and Mountain

oil on panel, 17 x 24 inches, 1993

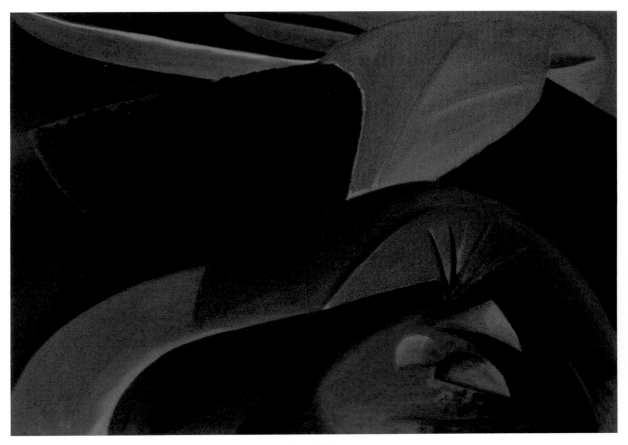

Red Sky

oil on panel, 17 x 24 inches, 1991

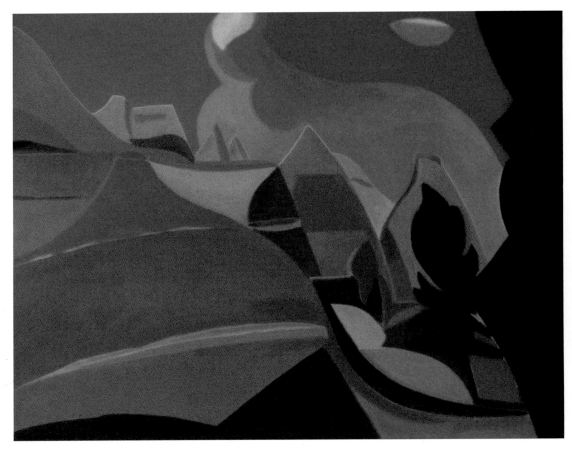

Tent Rocks

oil on panel, 14 x 18 inches, 2001

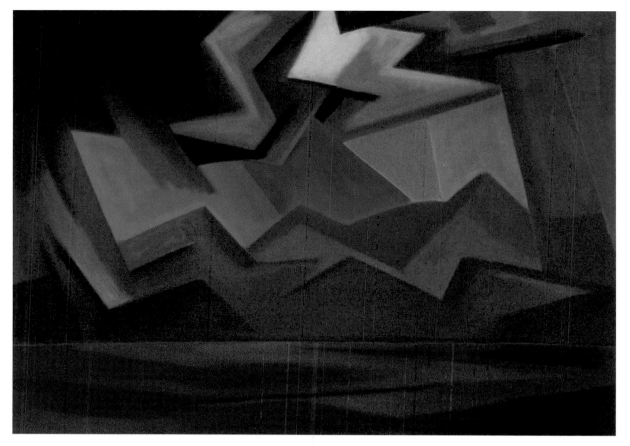

Rain and Mountains

oil on panel, 17 x 24 inches, 1993

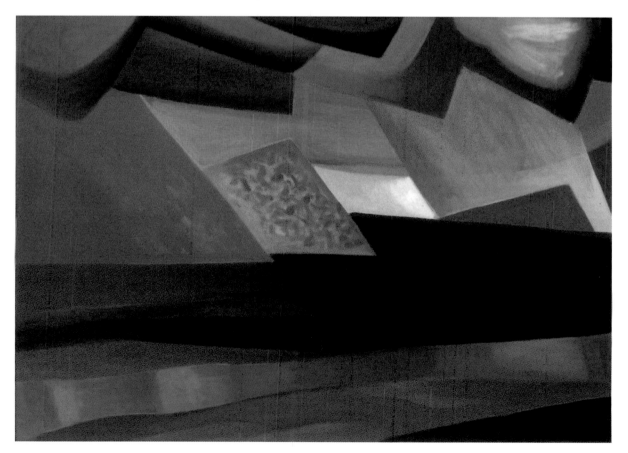

Rainstorm and Arroyo

oil on panel, 17 x 24 inches, 1991

WHITMAN JOHNSON

Photo by Robert Bell

50

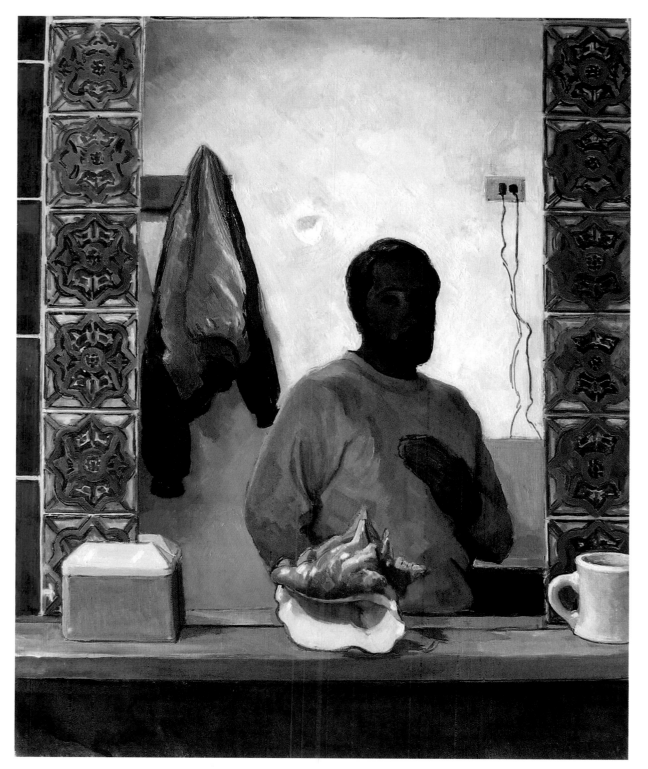

Self-Portrait

oil on canvas, 23 x 19 inches, 1992

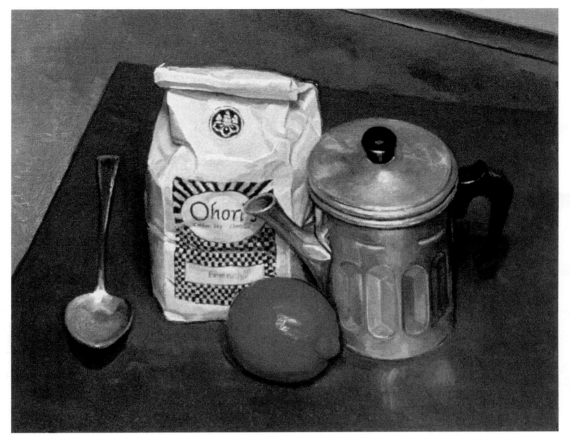

Coffee and Lemon I

oil on paper, 10 x 13 inches, 1994

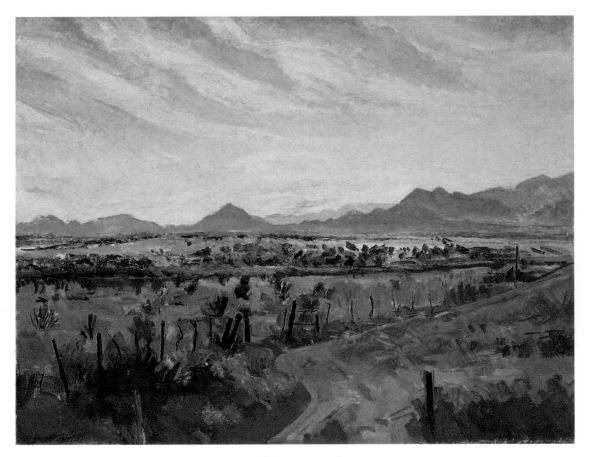

Galisteo Basin

oil on paper, 10 x 13 inches, 2000

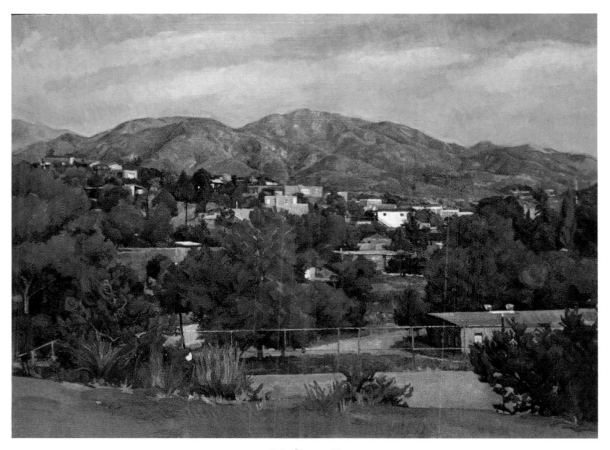

Atalaya II

oil on canvas, 17 x 23 inches, 1994-1995

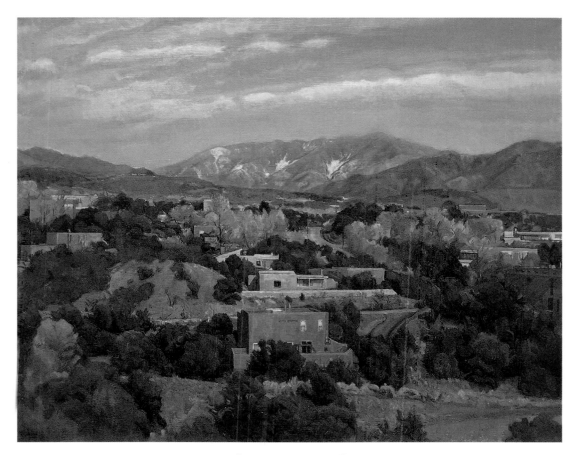

Thompson Peak

oil on canvas, 22 x 28 inches, 1998-1999

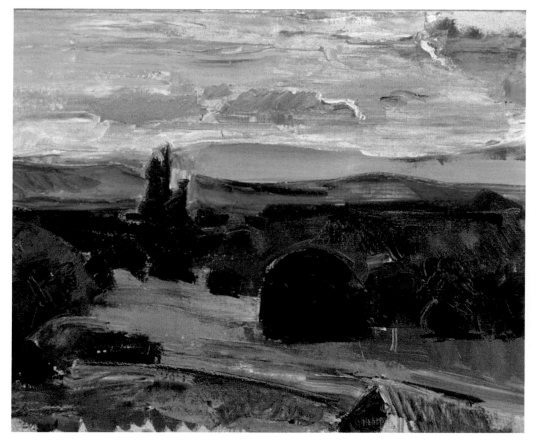

Jemez Mountains, Sunset

oil on canvas, 20 x 24 inches, 1979

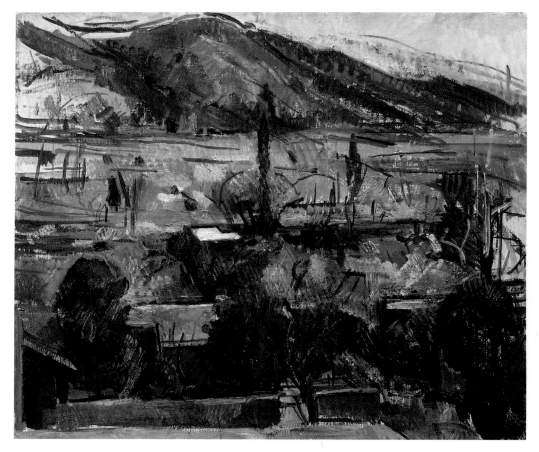

From Cerro Gordo Road

oil on canvas, 20 x 24 inches, 1979

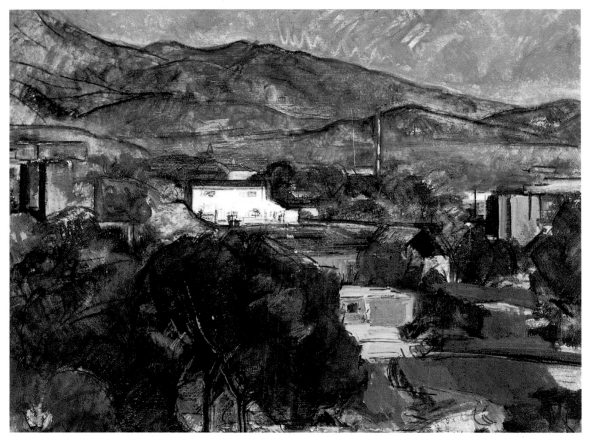

Santa Fe with Radio Tower

oil on paper, 14 x 18 inches, 1983

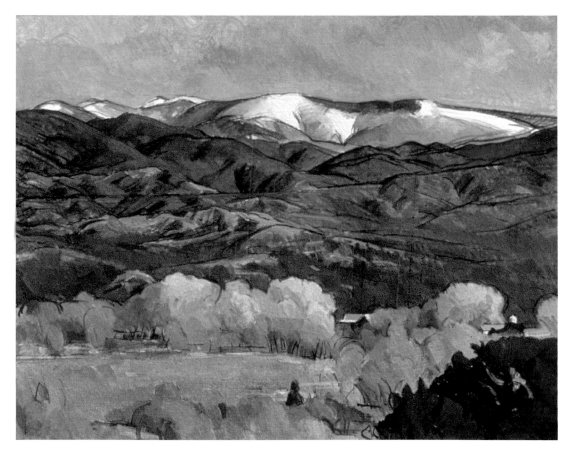

Sangre de Cristo Mountains

oil on paper, 10 x 13 inches, 1985

ZARA KRIEGSTEIN

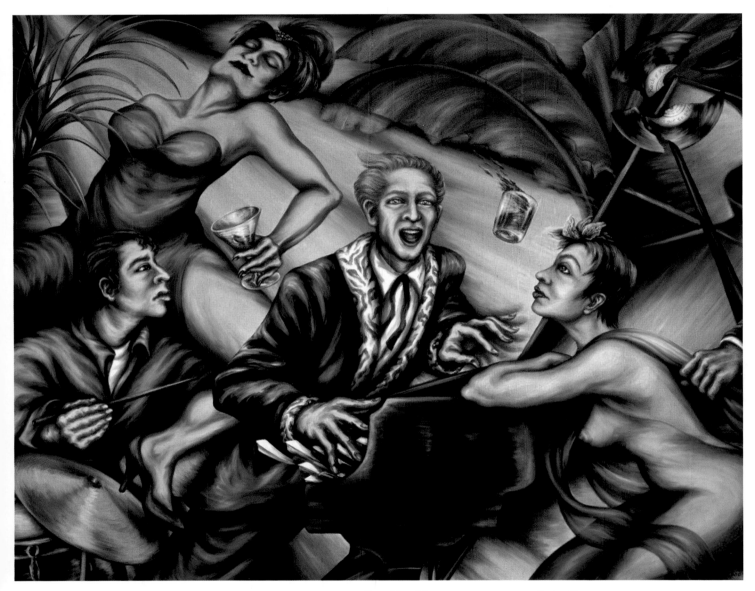

Homage to Jerry Lee Lewis: Shaking Heaven and Hell

acrylic on canvas, 56 x 72 inches, 2000

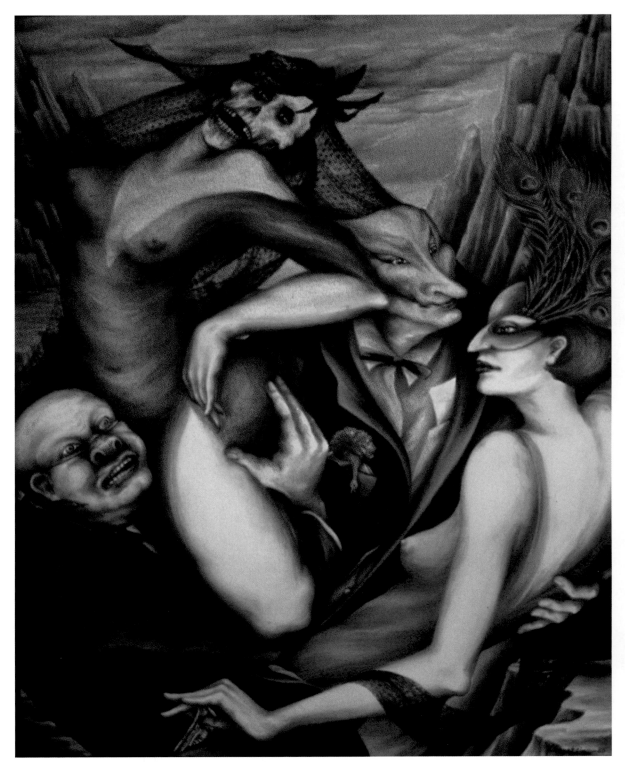

Halloween Everyday

oil on canvas, 52 x 40 inches, 1986

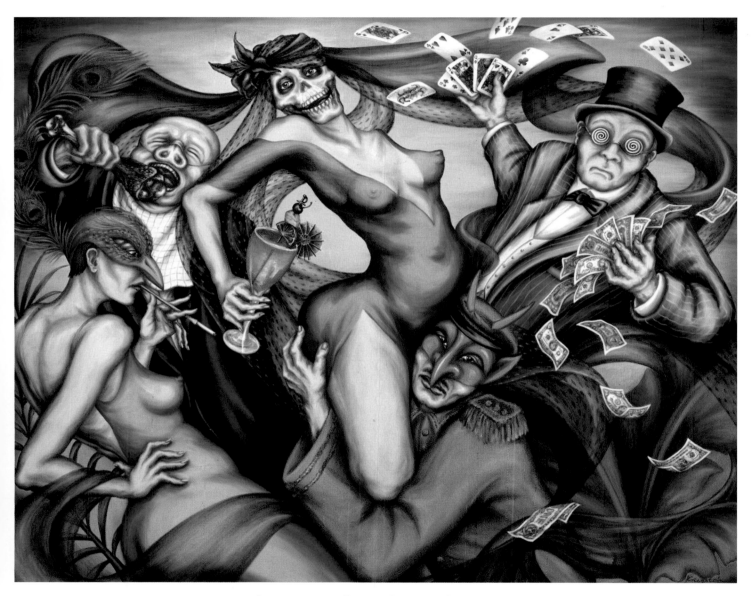

The Dance of Death Is Forbidden

acrylic on canvas, 60 x 76 inches, 1996

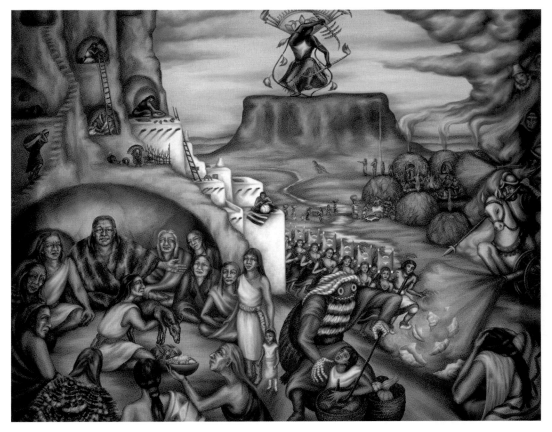

Pre-colonial Period

acrylic on canvas, 30 x 36 inches, 1994

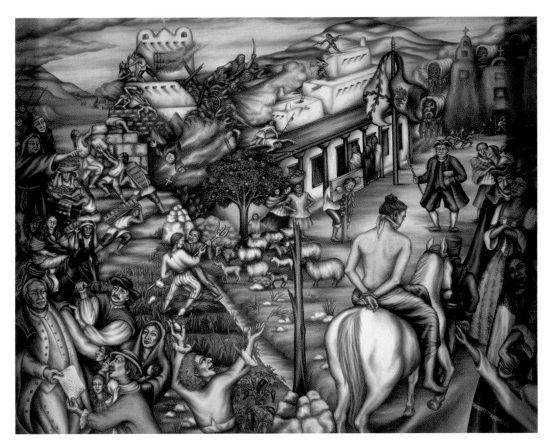

Colonial Period

acrylic on canvas, 30 x 36 inches, 1994

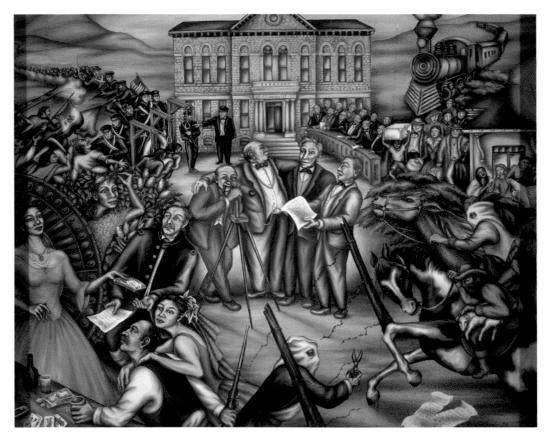

Territorial Period

acrylic on canvas, 30 x 36 inches, 1994

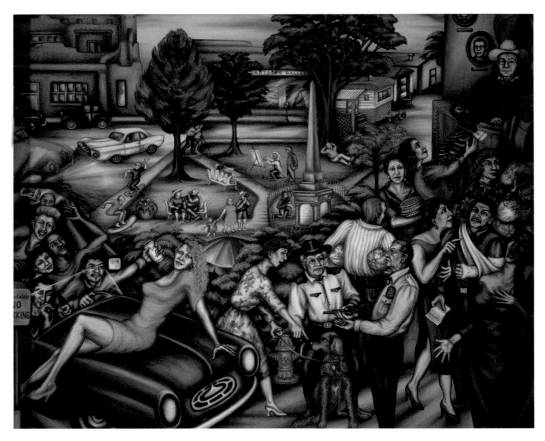

Contemporary Period

acrylic on canvas, 30 x 36 inches, 1994

GEOFFREY LAURENCE

Photo by Robert Bell

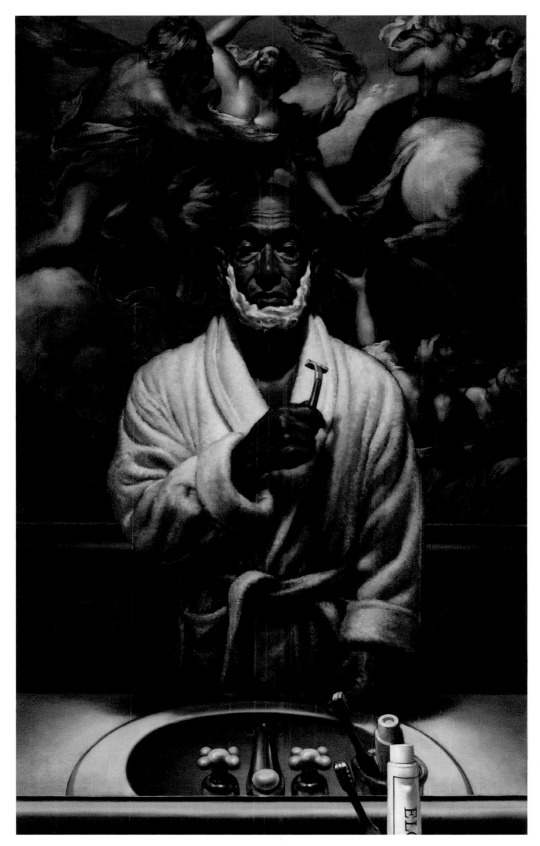

The Reckoning Point

oil on canvas, 30 x 48 inches, 2004

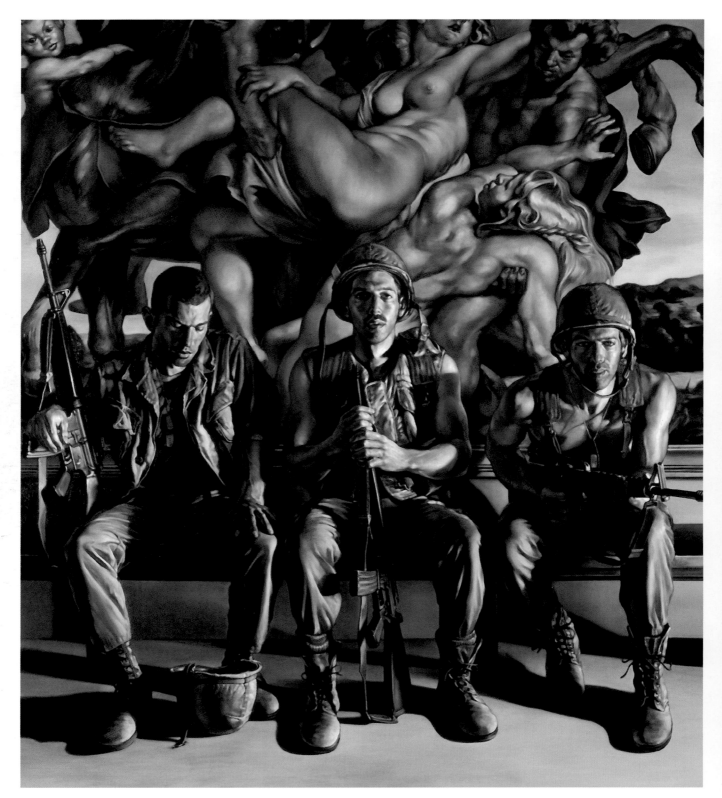

Hold Fast

oil on canvas, 78 x 74 inches, 2003

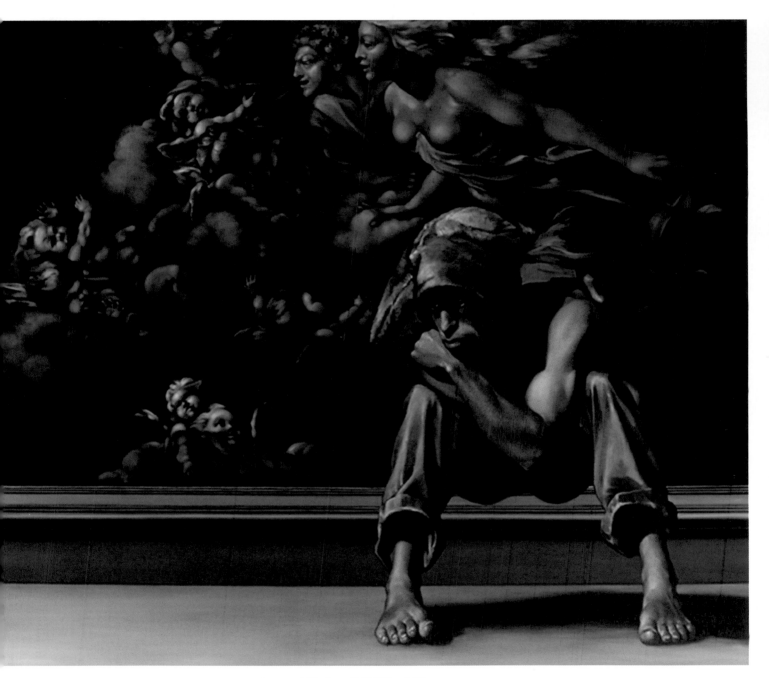

We're All Mad Here

oil on canvas, 60 x 68 inches, 2003

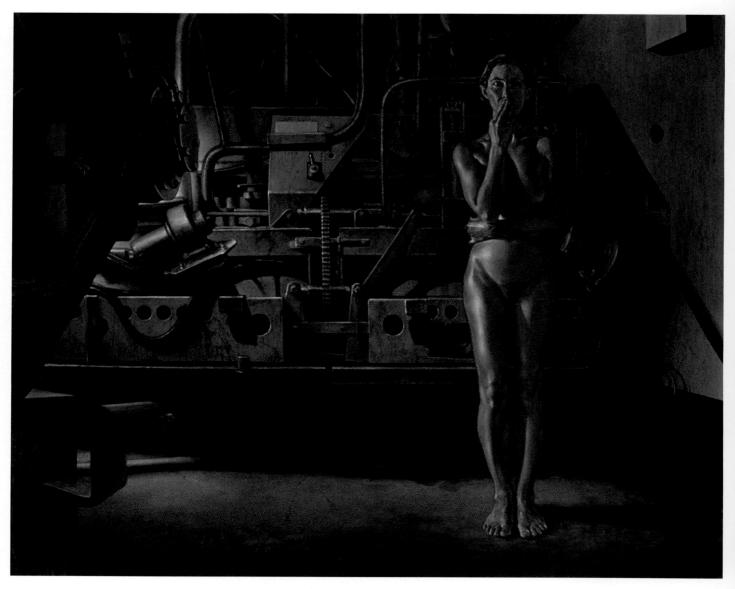

Hold Fast

oil on canvas, 58 x 72 inches, 2001

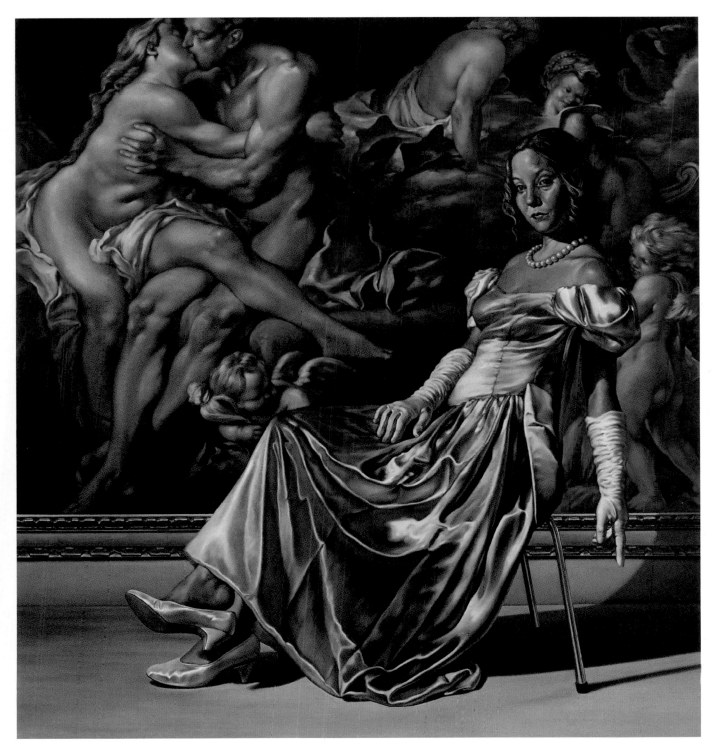

Promenade

oil on canvas, 64 x 60 inches, 2004

TREVOR LUCERO

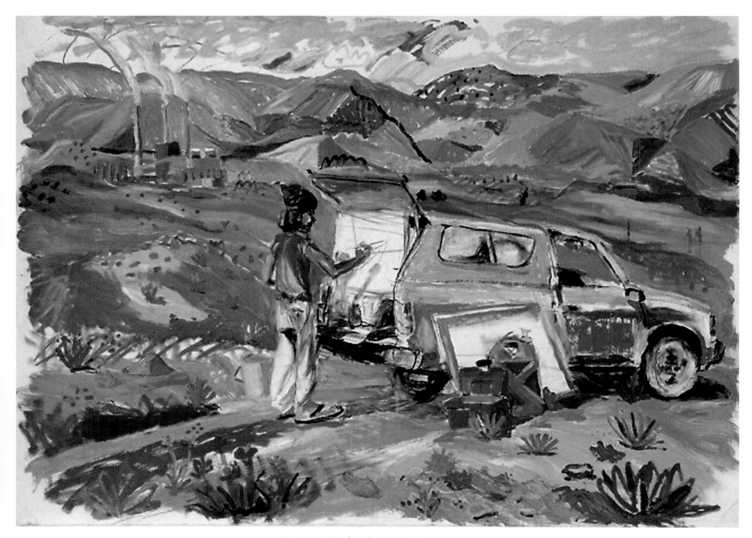

Tracy Painting a Factory

oil on paper on canvas, 32 x 46 inches, 2004

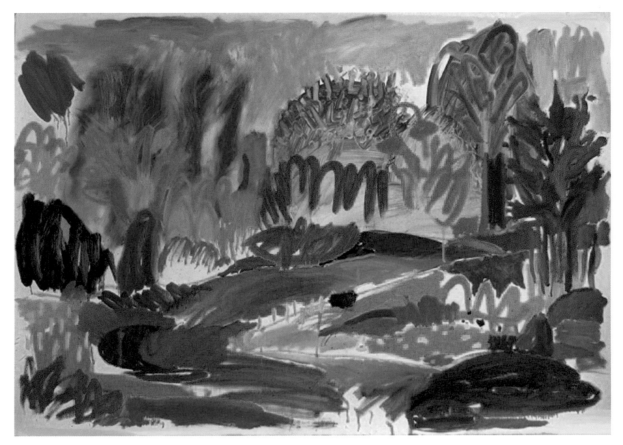

Alpine Road

oil on paper on canvas, 32 x 46 inches, 2004

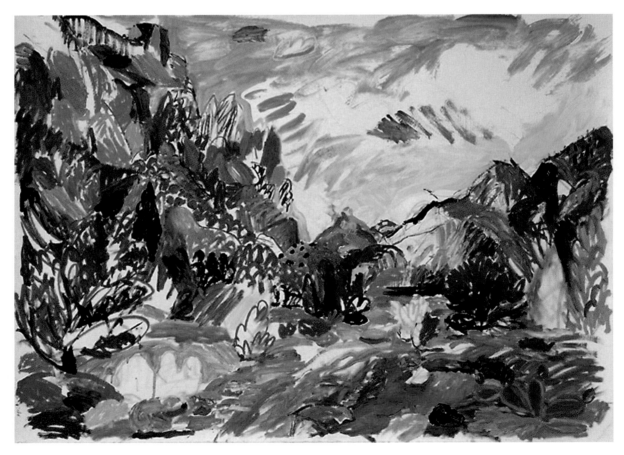

The Scene at Bull Mountain

oil on paper on canvas, 32 x 46 inches, 2004

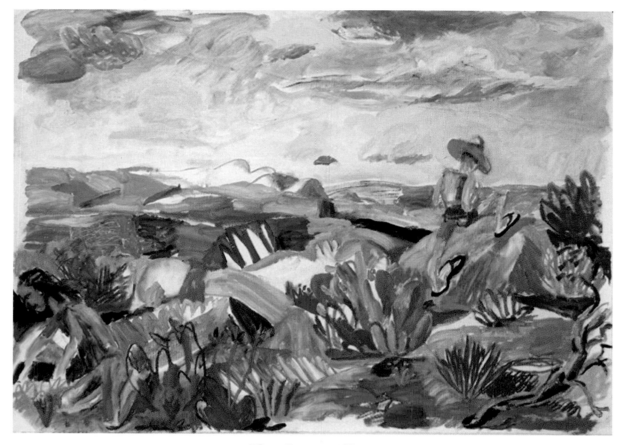

The Green Hiker

oil on paper on canvas, 32 x 46 inches, 2004

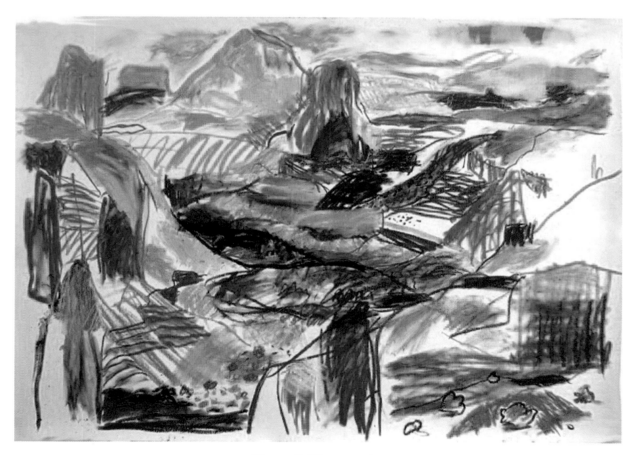

Desert Rhapsody

oil on paper on canvas, 32 x 46 inches, 2004

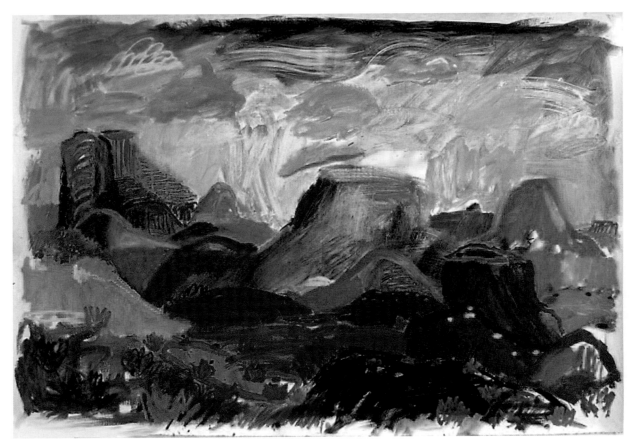

Submarines at the Wedge

oil on paper on canvas, 32 x 46 inches, 2004

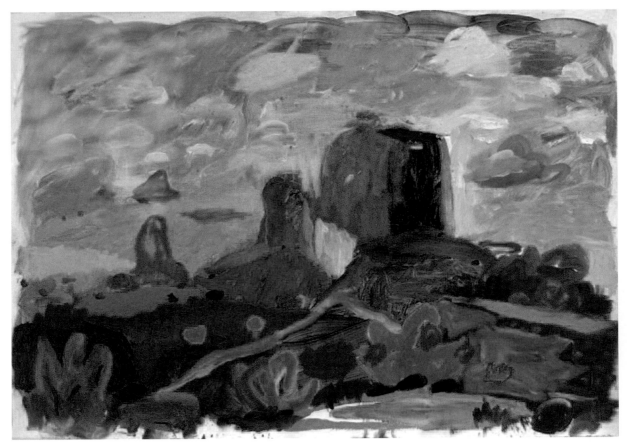

Mollie's Nipple

oil on paper on canvas, 32 x 46 inches, 2004

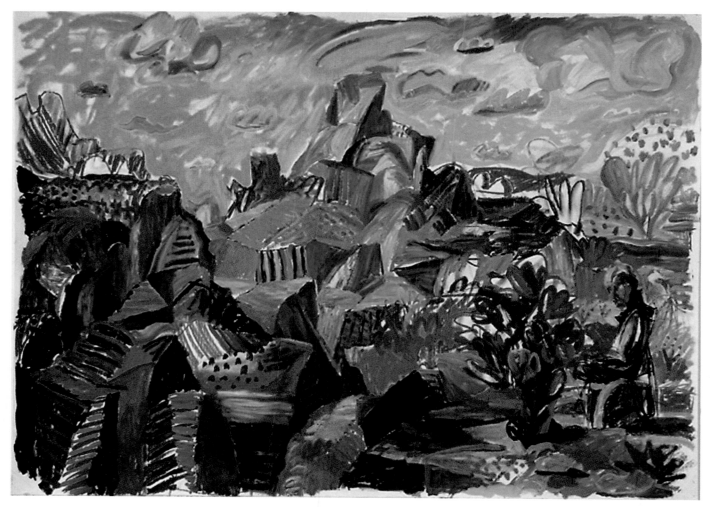

100 Years of Solitude

oil on paper on canvas, 32 x 46 inches, 2004

DAVID MAULDIN

Photo by Robert Bell

Marlboro Man and Sunset

oil on panel, 32 x 24 inches, 1986

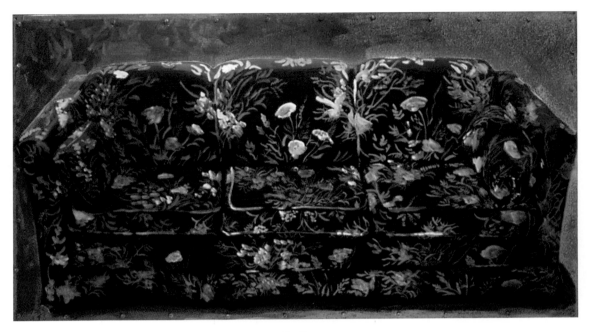

Sofa

urethane acrylic resin on masonite and steel, 24 x 48 inches, 1993

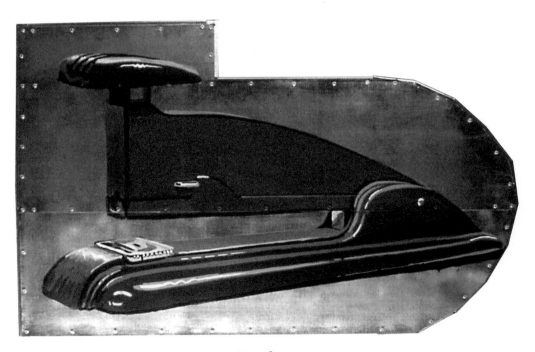

Stapler

urethane acrylic resin on galvanized steel, 29 x 46 inches, 1993

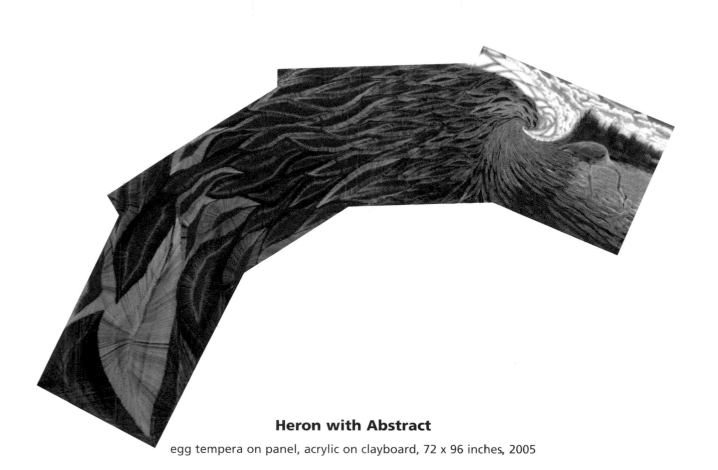

Heron with Abstract

egg tempera on panel, acrylic on clayboard, 72 x 96 inches, 2005

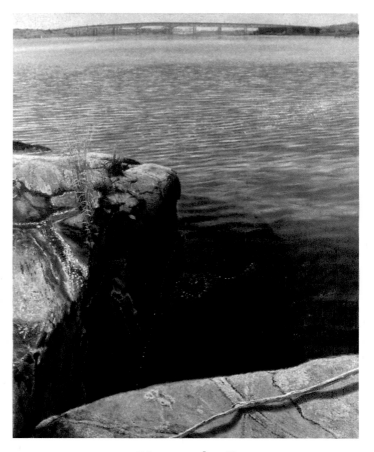

Mamacoke II

oil on panel, 36 x 24 inches, 1991

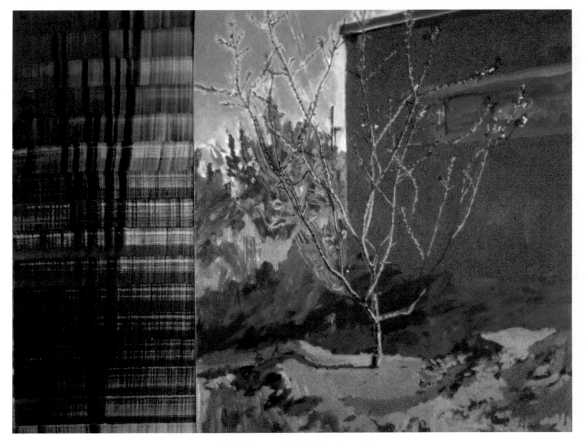

Adobe with Abstract

polymer emulsion and pigment on panel, 28 x 35 inches diptych, 2004

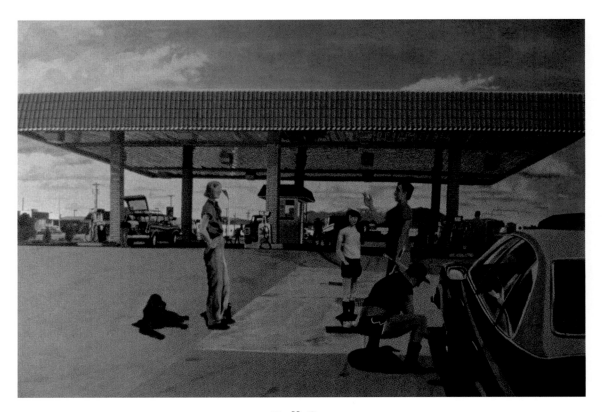

Bell Gas

oil on panel, 24 x 36 inches, 1984

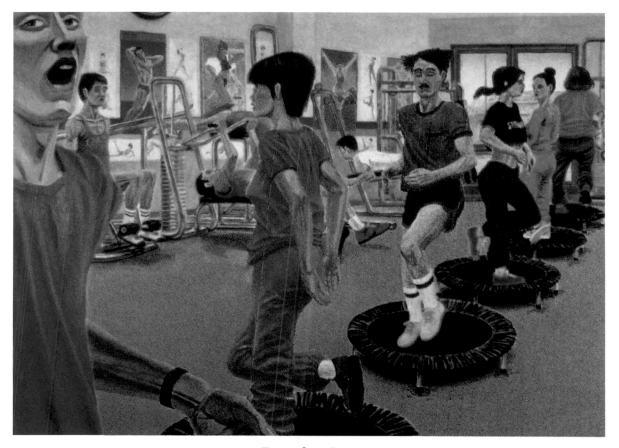

Exercise Spa

oil on panel, 26 x 32 inches, 1986

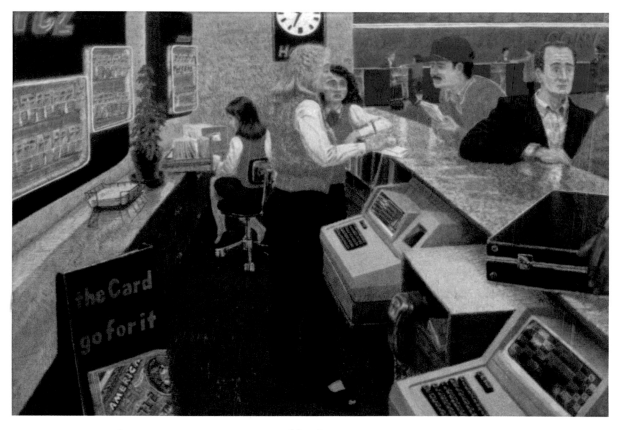

Hertz

egg tempera on panel, 16 x 24 inches, 1987

JACK SINCLAIR

Photo by Robert Bell

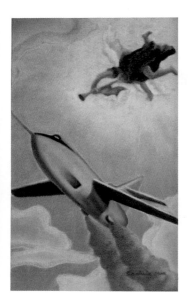

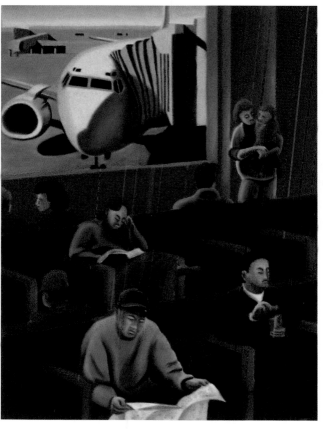

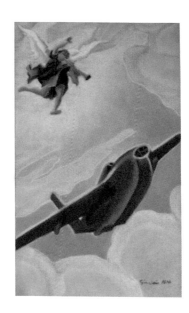

Rest on the Flight from Egypt

oil on canvas, 24 x 41 inches triptych, 2000

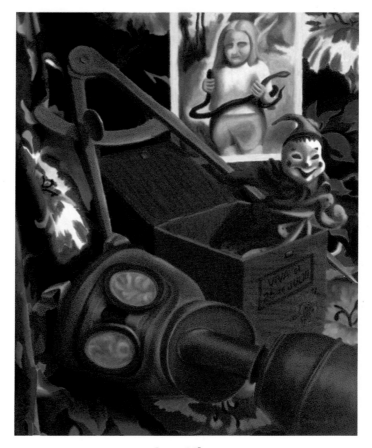

Que Viva

oil on canvas, 20 x 16 inches, 1996

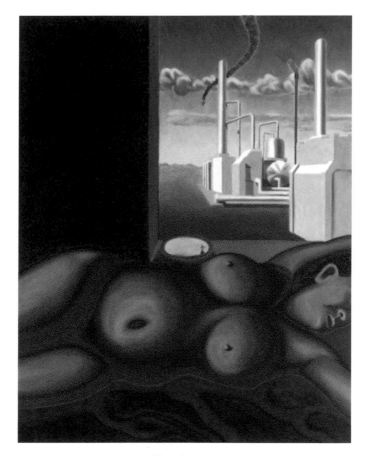

Fall of Icarus

oil on canvas, 40 x 32 inches, 1997

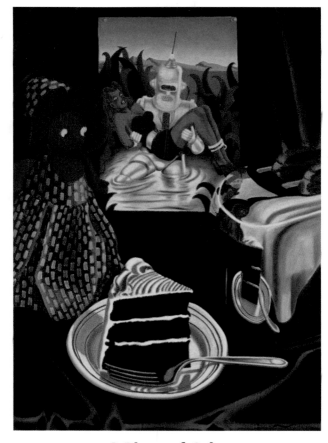

A Piece of Cake

oil on canvas, 28 x 21 inches, 1998

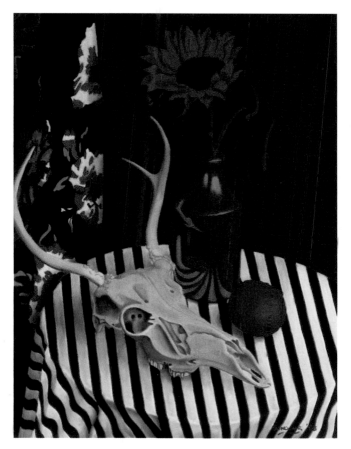

Still-Life with Deer Skull

oil on canvas, 24 x 18 inches, 1998

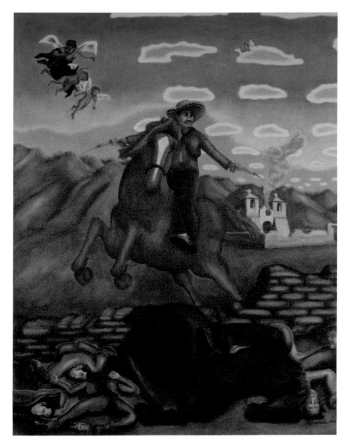

Pancho Villa

oil on canvas, 48 x 38 inches, 2003

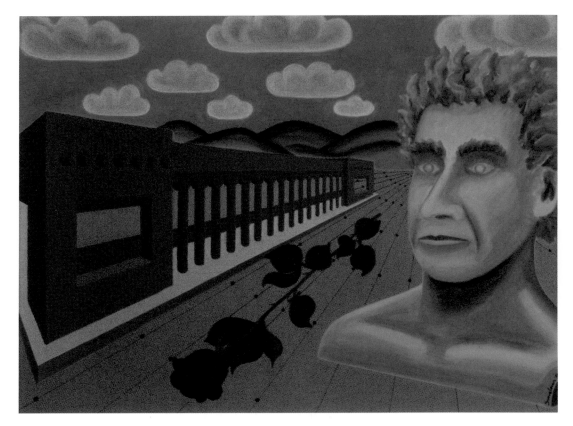

Arrival

oil on canvas, 18 x 24 inches, 1992

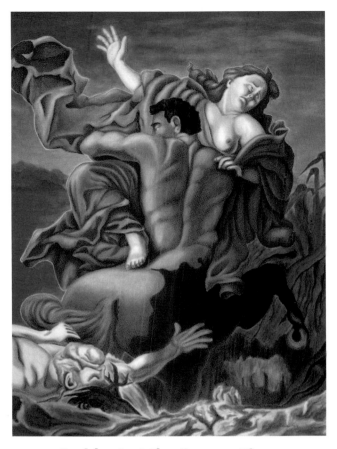

Incident at the Evenus River

oil on canvas, 48 x 36 inches, 2000

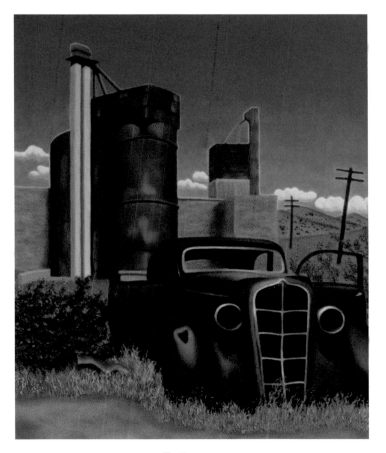

Entropy

oil on canvas, 30 x 25 inches, 1997

Photo by Robert Bell

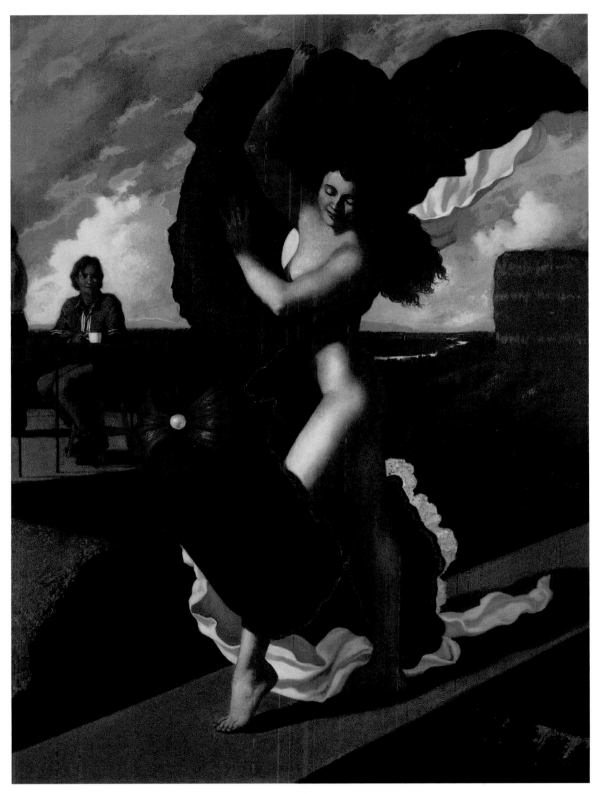

Precarious Muse

oil on paper, 18 x 15 inches, 1998

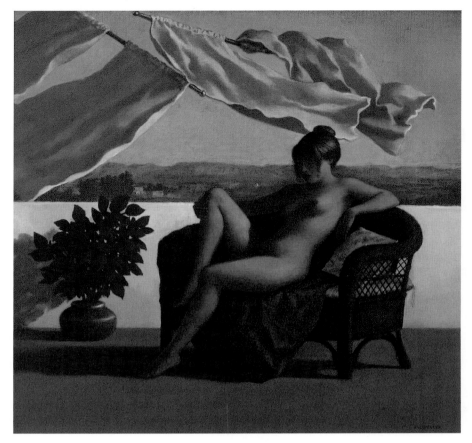

The Gordian Knot Untied

oil on canvas on panel, 12.5 x 13.5 inches, 1997

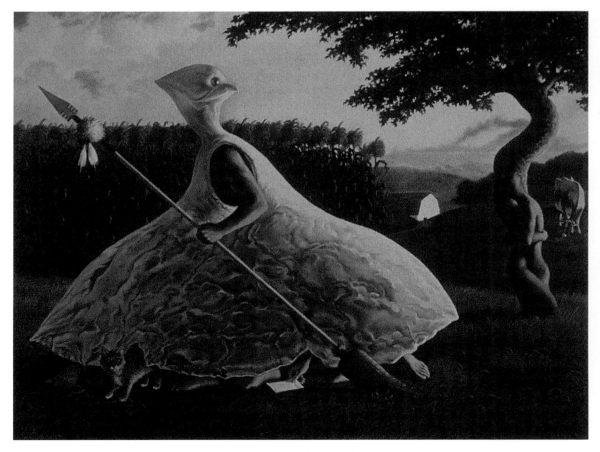

The Early Bird

oil on canvas on panel, 12 x 15 inches, 1990

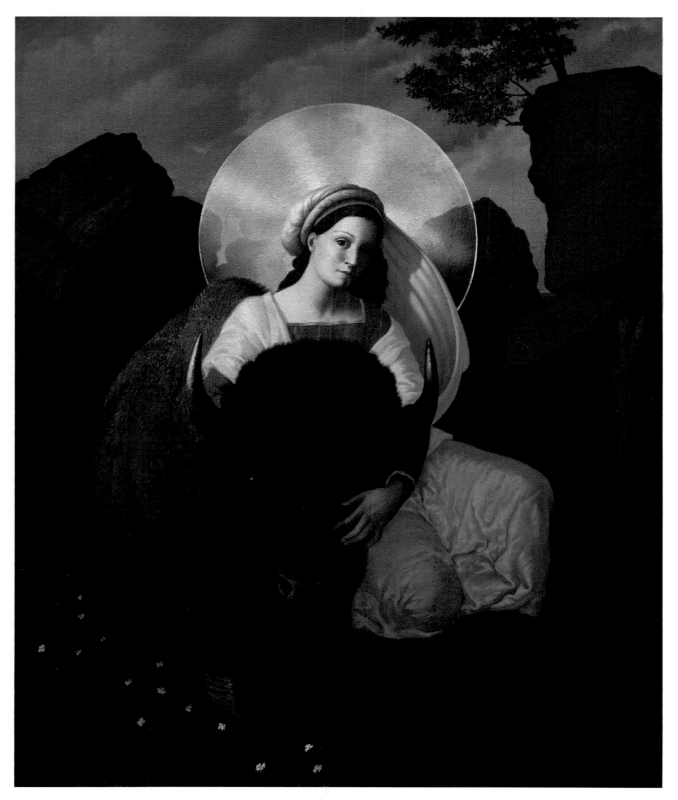

The Bison Madonna

oil on canvas, 20 x 16 inches, 1991

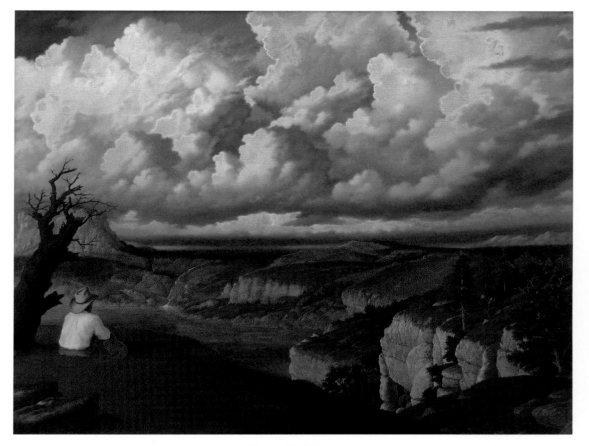

Ghost Riders

oil on canvas, 34 x 38 inches, 1990

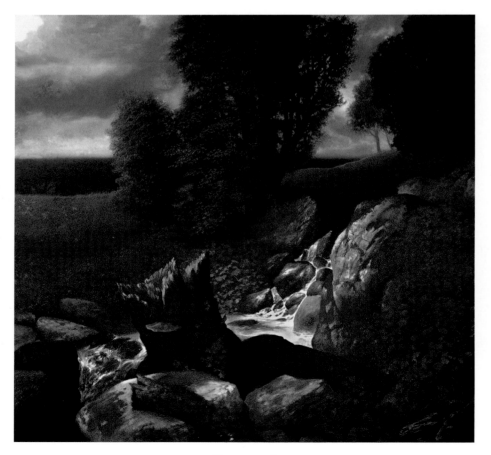

Overcast

oil on canvas, 28 x 30 inches, 1989

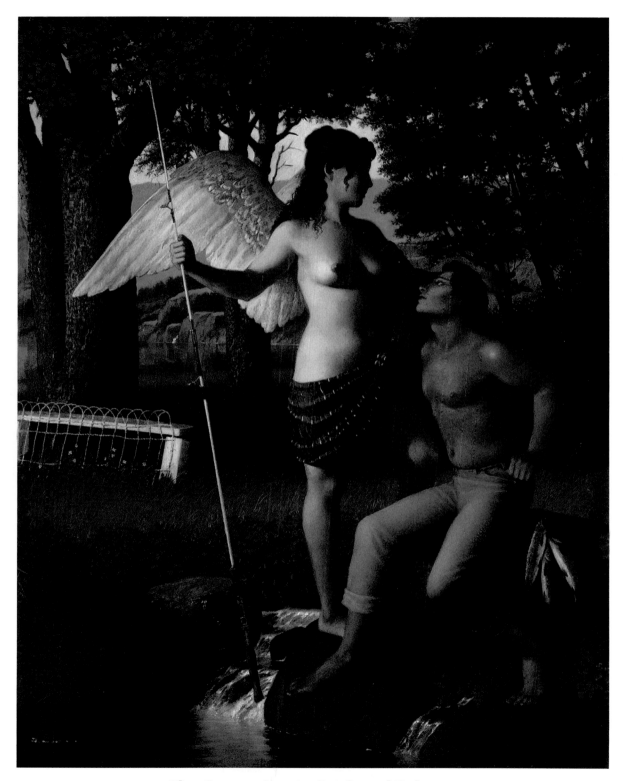

The Conversion to Catch and Release

oil on canvas, 18 x 14 inches, 2000

MARK SPENCER

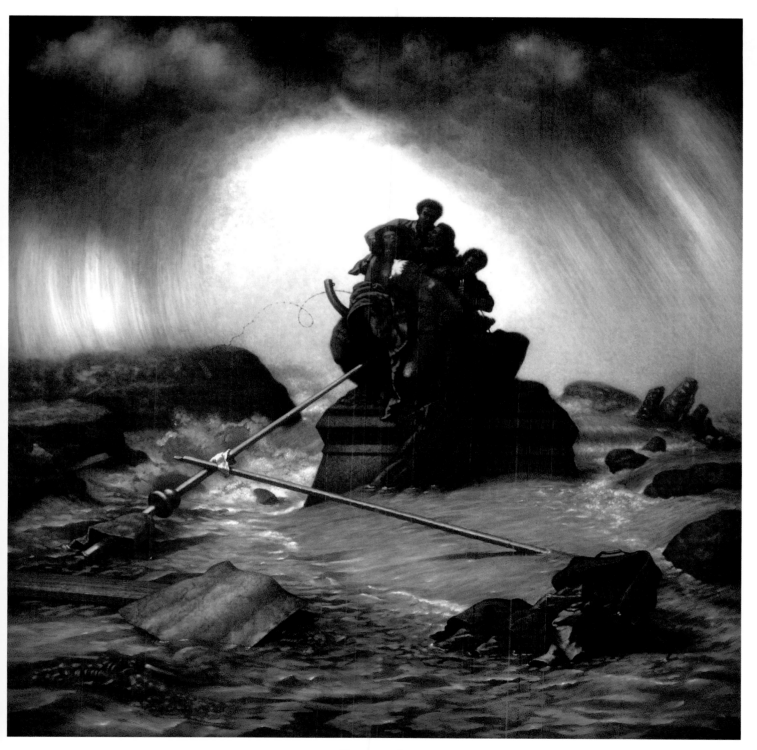

Tempest

oil on canvas, 48 x 48 inches, 2003

St. Michael

oil on panel, 12 x 12 inches, 2003

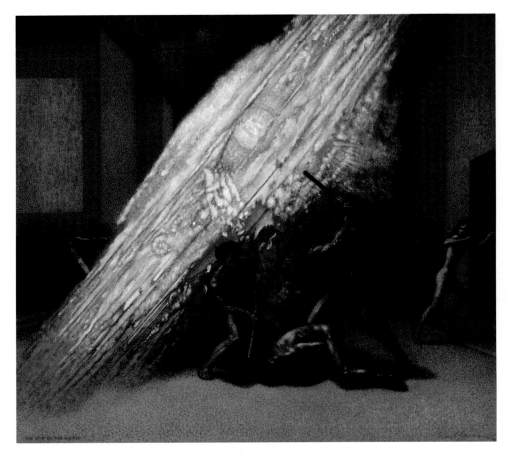

Eye of the World

oil on panel, 18 x 20 inches, 1991

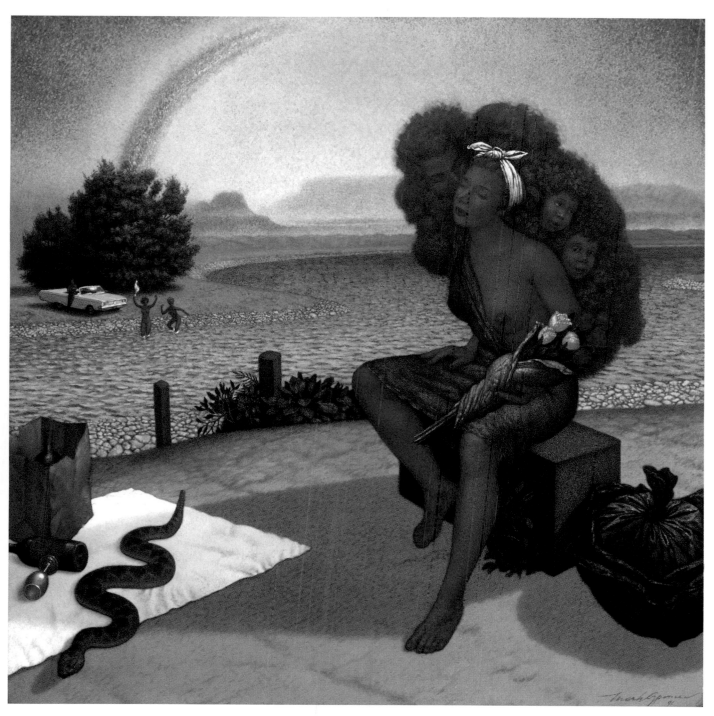

Love's Return

oil on panel, 24 x 24 inches, 1991

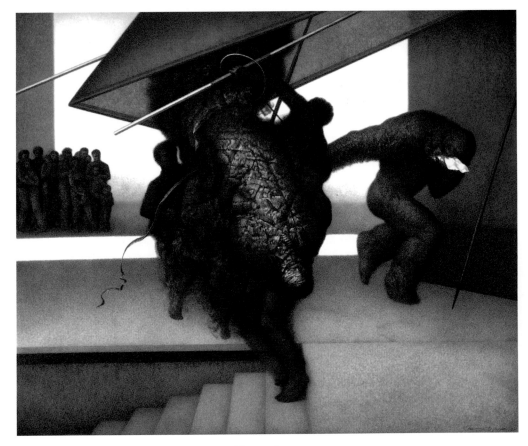

Requiem

oil on canvas, 78 x 90 inches, 2000

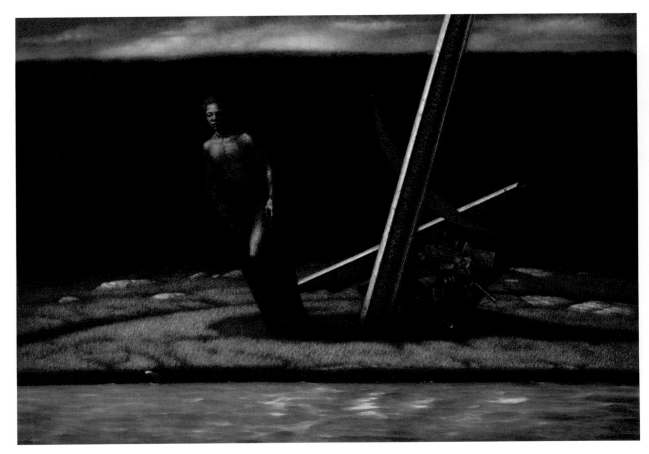

Adam

oil on canvas, 58 x 84 inches, 2000

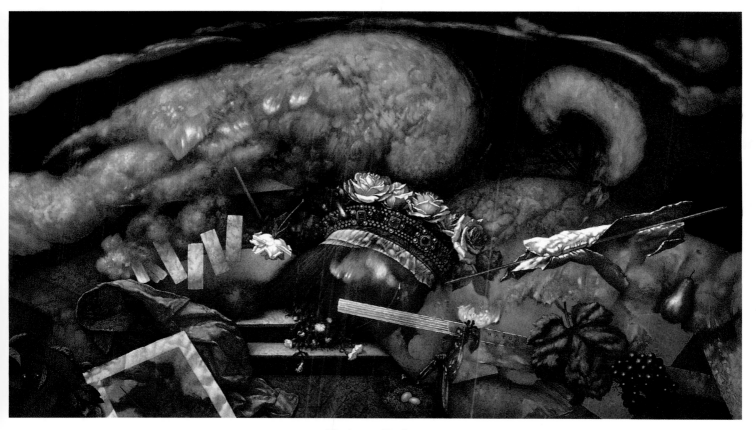

Nature Rules

oil on canvas, 34 x 60 inches, 1994

JODY SUNSHINE

Photo by Robert Bell

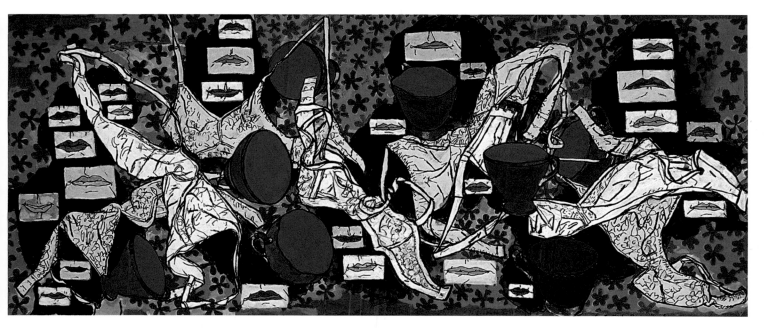

Advice to the Lovelorn

acrylic on board, 15 x 36 inches, 2004

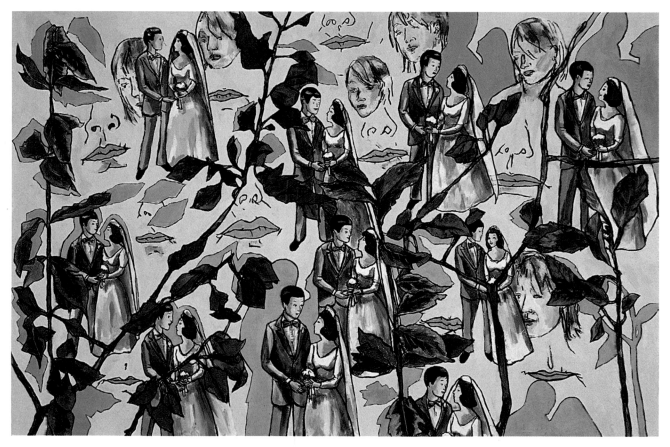

Just Before the Bride Fainted

acrylic on board, 20 x 29 inches, 2004

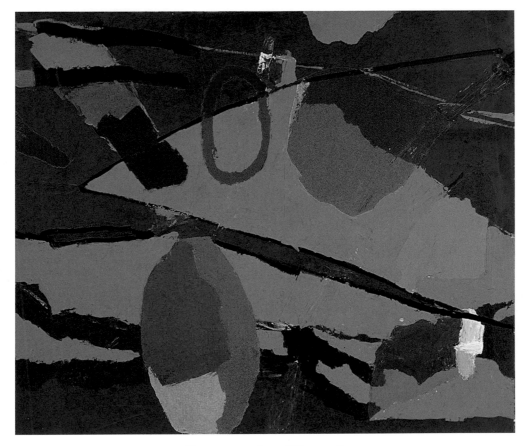

Encouraging Dissent

acrylic on canvas, 28 x 32 inches, 1994

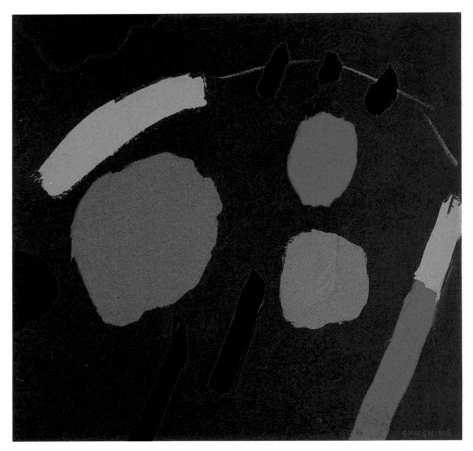

Visiting Gertrude

acrylic on canvas, 21 x 22 inches, 1994

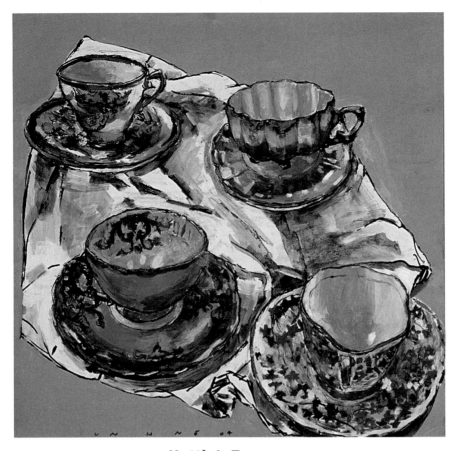

Hattie's Teacups

acrylic on board, 12 x 12 inches, 2004

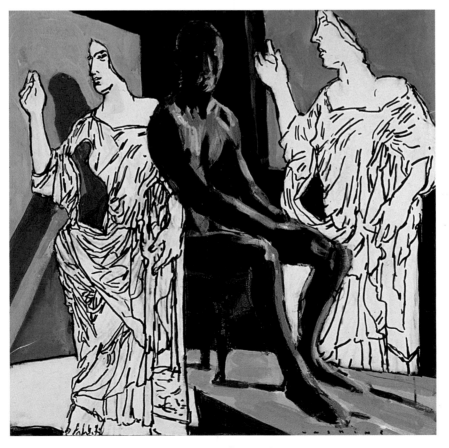

Time and Again

acrylic on board, 12 x 12 inches, 2004

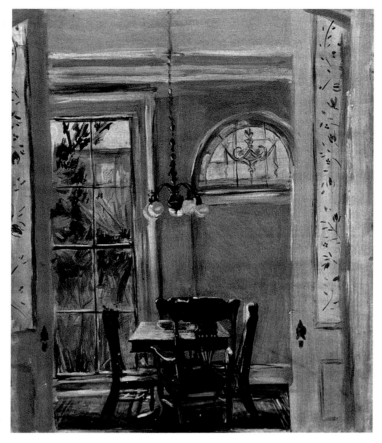

Brooklyn Rear Parlor

acrylic on board, 11 x 13 inches, 1975

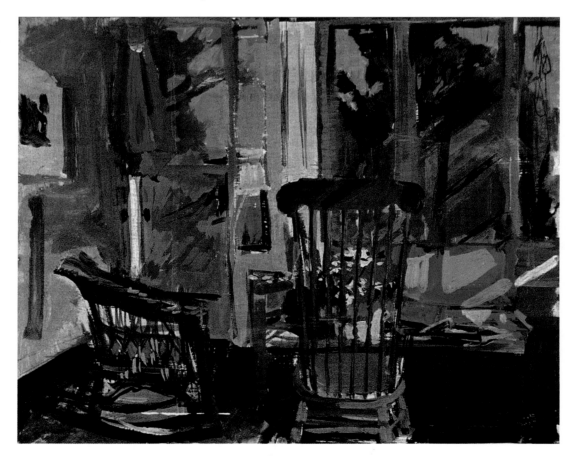

Fire Island in July

acrylic on board, 10 x 13 inches, 1975

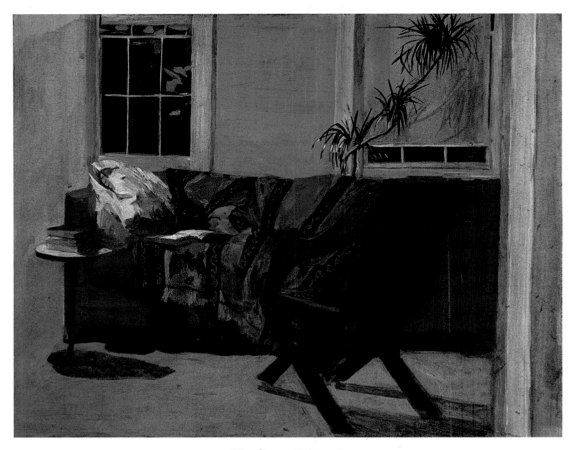

Hudson Street

acrylic on board, 10 x 13 inches, 1975

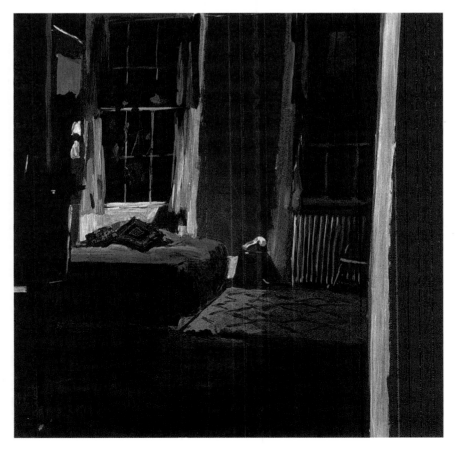

Diane's House

acrylic on board, 11.5 x 11.5 inches, 1975

JERRY WEST

Photo by Robert Bell

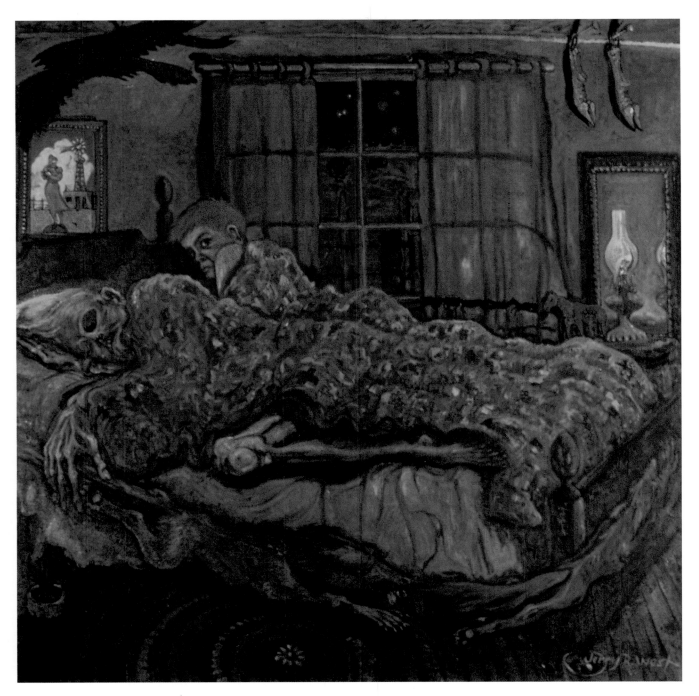

Night Passage

oil on canvas, 46 x 46 inches, 1987

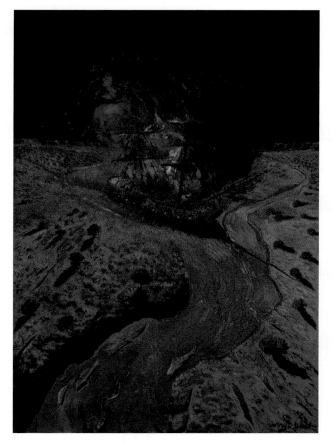

Preemptive Intrusion – Prairie Fires Beginning

oil on canvas, 96 x 72 inches, 1989

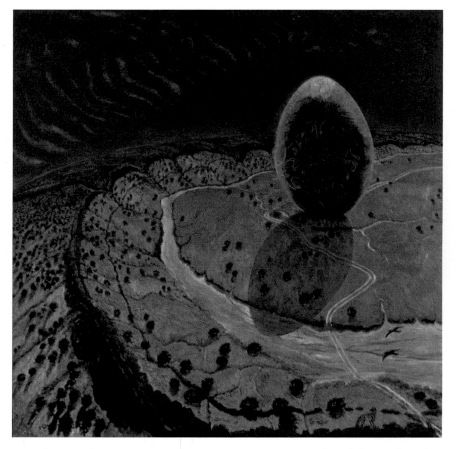

Embryonic Convergence – New Egg with Old Hogback

oil on canvas, 60 x 48 inches, 1994

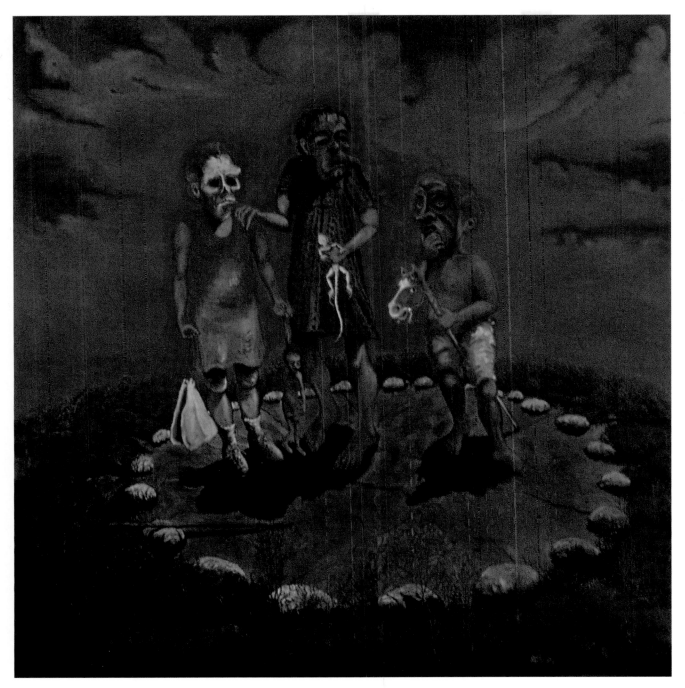

Prairie Children with Masks

oil on canvas, 74 x 74 inches, 1988

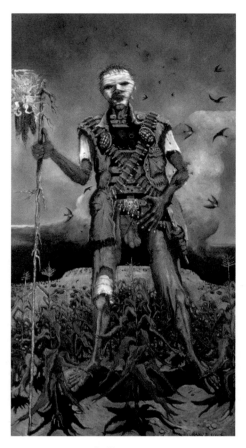

Imperial Scarecrow

oil on canvas, 101 x 57 inches, 1987

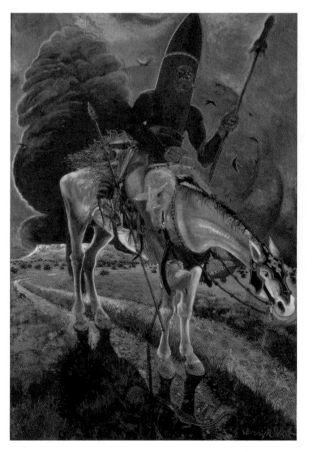

Return of the Nuclear Warrior

oil on canvas, 84 x 60 inches, 1989

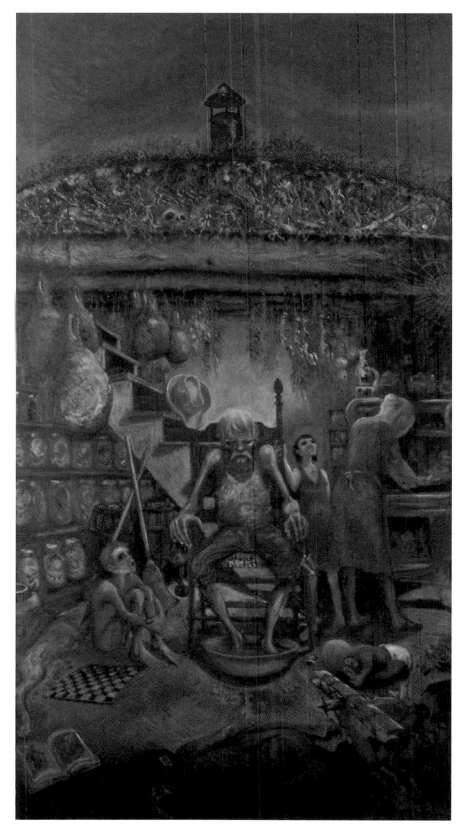

Nuclear Family in Nuclear Fallout Cellar

oil on canvas, 101 x 57 inches, 1988

MICHAEL WRIGHT

Photo by Robert Bell

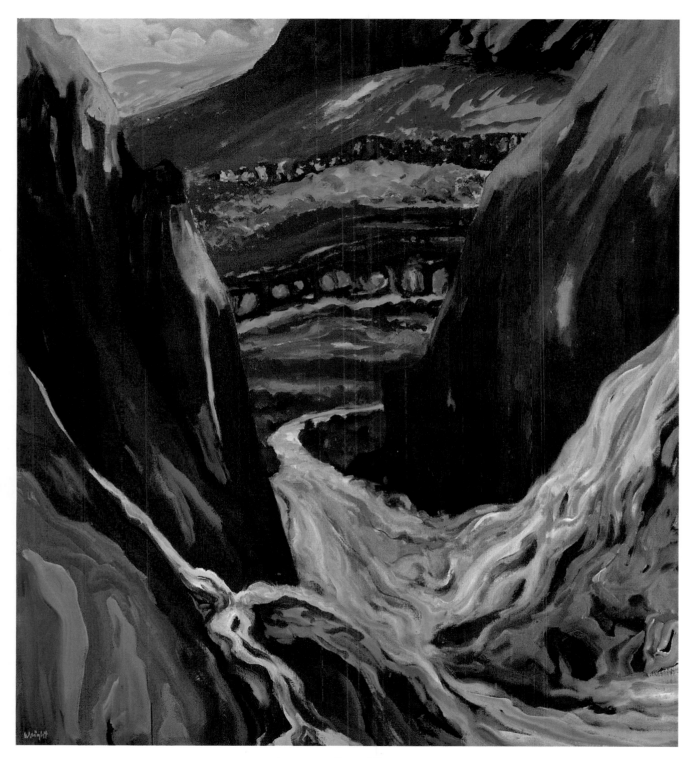

Converging Waters

oil on linen, 46 x 50 inches, 1998

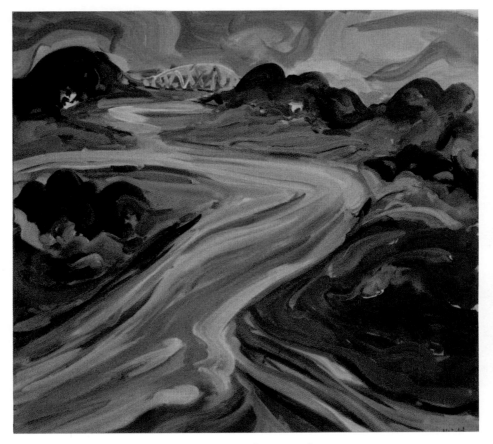

Portsmouth Marsh

oil on linen, 36 x 45 inches, 1982

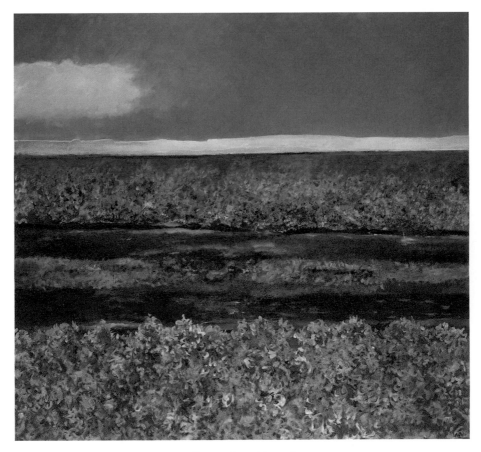

Country Road

oil on linen, 46 x 50 inches, 1988

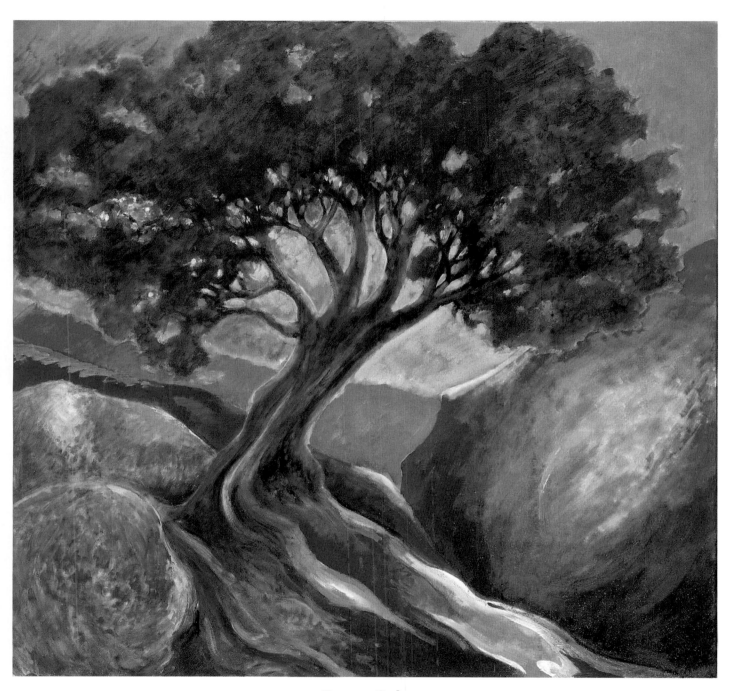

Emery Oak

oil on linen, 42 x 44 inches, 1989

Rocks on Burr Trail I

oil on linen, 46 x 50 inches, 1987

Landscape

mixed media on canvas, 50 x 54.75 inches, 2003

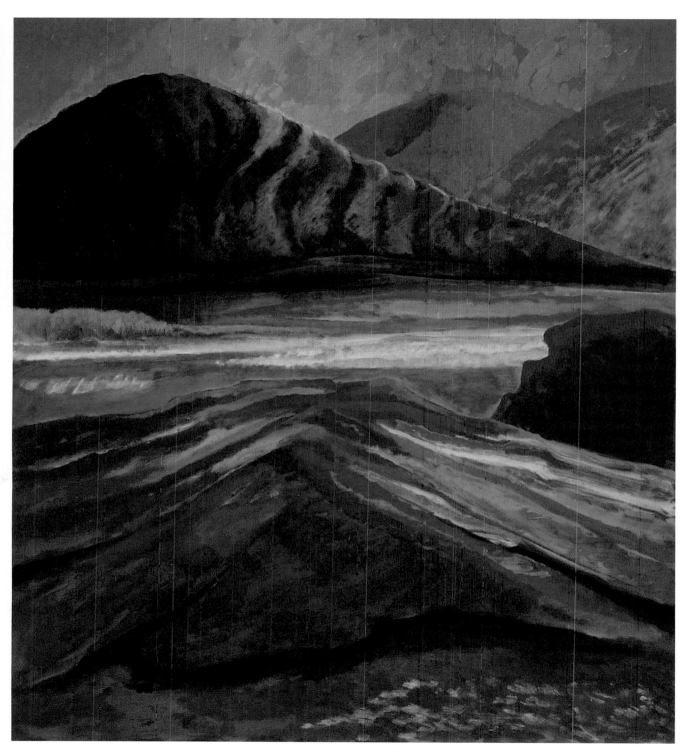

San Luis Valley

oil on linen, 50 x 46 inches, 1988

LENDERS TO THE EXHIBITION:

Rick Boot
Los Angeles, CA

Mary L. Brown
Santa Fe, NM

Celia and Al Castillo
Santa Fe, NM

Patti and Eric Cole
Santa Fe, NM

Dr. Dennis and Julie Downey
Santa Fe, NM

George Goldstein
Santa Fe, NM

Kerry Green
Santa Fe, NM

Bob and Carol Inman
Denver, CO

Milton Johnson
Santa Fe, NM

Sally and Don Romig
Santa Fe, NM

Phyllis Sloane
Santa Fe, NM

Larry Sparks
Santa Fe, NM

Work by Dennis Flynn is exhibited by
Eldridge McCarthy Gallery, Santa Fe, NM

Work by Joel Greene is exhibited by
Ernesto Mayans Gallery, Santa Fe, NM

Work by Geoffrey Laurence is exhibited by
LewAllen Contemporary, Santa Fe, NM

Work by David Mauldin is exhibited by
Klaudia Marr Gallery, Santa Fe, NM

Work by Jack Sinclair is exhibited by
Eldridge McCarthy Gallery, Santa Fe, NM

THE PUBLISHER

Robert Bell lives in Santa Fe and is a practicing ophthalmologist. He has collected prints for over four decades, with special expertise in nineteenth- and early twentieth-century European and American artists. A major donor of original prints to universities and museums, he has lectured widely on the history and techniques of printmaking. Dr. Bell has also been an extensive patron of printmaking artists in Santa Fe since 1980.

THE AUTHOR

James Mann is Curator-at-Large of the Las Vegas Art Museum, where he has originated over fifty exhibitions since 1996, half of them accompanied by catalogues. He holds a doctorate in literature with an interdisciplinary fine-arts emphasis, and has taught at several universities. He also has written reviews and essays on the visual arts in a variety of national and regional publications. He is also the author of two forthcoming books: Beyond Post-modernism, a work of art theory, and AZ-USA, a book-length poem.

COLOPHON

This book was printed by Nevada Color Litho for the Bell Tower Editions in a softbound edition of 2300. A hardbound deluxe edition was also published with two prints by Zara Kriegstein, numbered 1 to 150, each book containing two original signed color lithographs: The Blues and Halloween Everyday, both printed on Arches cover white. The original graphics were printed by James Bourland at his Borderline Press in Santa Fe, New Mexico.

This is copy number _____

THE SANTA FE PRINTMAKERS SERIES

Santa Fe, New Mexico, is home to one of the major artist communities in the United States. In an artistic tradition going back to the colonial period of the city's history, many Santa Fe artists today are not only exceptional painters, but are also skilled original printmakers. These painter-printmakers use all the techniques available for creating original prints, from woodcut to etching, from lithography to serigraphy. The present exhibition and its catalogue include paintings only, but some of the exhibited artists are also printmakers, and will be the subject of future volumes in this printmakers series from Bell Tower Editions. The series will also eventually produce catalogues raisonnés of the print work of a number of prominent Santa Fe painter-printmakers.

Titles in the Santa Fe Printmakers Series already published:

Eli Levin: Scenes of Santa Fe Nightlife

Phyllis Sloane: Retrospective Exhibition, Las Vegas Art Museum

Artists whose print work will be the subject of future titles in this series:

William Gonzales

Hal West

Zara Kriegstein

Joel Greene

Michael Wright

Mark Spencer

Jerry West